Monet's PASSION

IDEAS, INSPIRATION & INSIGHTS
from the PAINTER'S GARDENS

Elizabeth Murray

Pomegranate
SAN FRANCISCO

Published by Pomegranate Communications, Inc.
Box 808022, Petaluma, CA 94975
800 227 1428 | www.pomegranate.com

Pomegranate Europe Ltd.
Unit 1, Heathcote Business Centre, Hurlbutt Road
Warwick, Warwickshire CV34 6TD, UK
[+44] 0 1926 430111 | sales@pomeurope.co.uk

Library of Congress Cataloging-in-Publication Data
Murray, Elizabeth, 1953-
 Monet's passion : ideas, inspiration, and insights from the painter's
gardens / Elizabeth Murray. -- Rev. ed.
 p. cm.
 Includes bibliographical references.
 ISBN 978-0-7649-5389-7 (hardcover)
 1. Monet, Claude, 1840-1926--Homes and haunts--France--Giverny.
2. Gardens--France--Giverny. 3. Landscape gardening. 4. Gardens--
Design. I. Title.
 ND553.M7M87 2010
 759.4--dc22
 2009043395

Pomegranate Catalog No. A181

Designed by Harrah Lord | www.yellowhousestudio.info

Printed in China

19 18 17 16 15 14 13 12 11 10 10 9 8 7 6 5 4 3 2 1

Dedication

*To all garden artists who
work with nature to create
gardens as their art.*

Contents

~ Acknowledgments ~

My special appreciation and indebtedness to the late Gérald and Florence van der Kemp, who invited me to live and work in the gardens in 1985; Mme Lindsey, director of the Musée Claude Monet, who continues to welcome me annually; M. Vahé, the head gardener who accepted me as the first woman gardener, and all the staff; the late Jean-Marie Toulgouat, Monet's step-great-grandson, who grew up in the gardens, and his author wife, Claire Joyes, who shared Monet's life with me and enriched mine. My gratitude continues for my French friends Marcelle Boyer, who first brought me to Giverny; Mark Brown, the Mallet family, and Princess Sturdza, who introduced me to the fine art of gardening; and Sabine Du Tertre, who taught me about the patchwork of gardening.

To my dear American friends and family, thank you for your continued love, support, and belief in this project, both the first time and now. Thank you with all my heart to Ellie Rilla, Kay Cline, Debra Davalos, and Roelof and Virginia Wijbrandus for continual loving support and enthusiasm; Dr. Chuck Quibell, who checked the Latin plant names; Sandy Rader, Elaine Schlegel, and Jeanne Cameron, who follow the beauty way with flowers and celebrations; Anna Rheim and Jane Olin, who coached me from the heart; Jeff and Susan Turner, my amazing Ayurveda healers, and David Fuess, who keep me healthy; Penny Allport, who moves with grace; Terry Reeves and David Baum, weavers of creative community; artist gardener Helene Daniels, who taught me the joys of water gardening; ranchers Jeanne and Robert Bradford, who know the beauty of place over time; Betty Peck and Anna Rainville, who know children learn best in the garden; Melany and Duncan Berry, artists who bring children to nature; Lily Yeh, who transforms and heals broken places and people with beauty and art; gardener and medicine woman Margot Grych; Lynn Twist, who mentored my first two forays into the Amazon rainforest to learn from indigenous people; Rebecca Dye, Jody Snyder, and Jo Anderson, nature artists and adventure friends; my mentors of wisdom, Kathleen Burgy and Angeles Arrian, who carry the light; Jenny Fry for courage, humor, and beauty; Matt Regan for cheerleading; Kenneth Parker and Tom Deyerle, who pulled me out of tech challenges; and my beautiful spirit daughters, Julie Froekjaer, Sahara Saude, and Rebecca Murray, who follow their hearts and the beauty way. Gratitude and love to my family, especially the children—Grace, an artist who loves nature, and Taylor, who loves to play and create. Special thanks again to Heather O'Connor, who took my layouts of Monet's gardens and beautifully illustrated them (see pages 24–27); my editor, Judy Mazzeo, who lovingly pruned and weeded my abundant manuscript; assistant publisher Stephanie King, who patiently kept me on track; and Harrah Lord, who with thoughtful beauty and finesse designed this all-new edition. Lastly, to Katie and Tom Burke, who have published my work in books, calendars, and cards for decades, thank you with deep appreciation and gratitude.

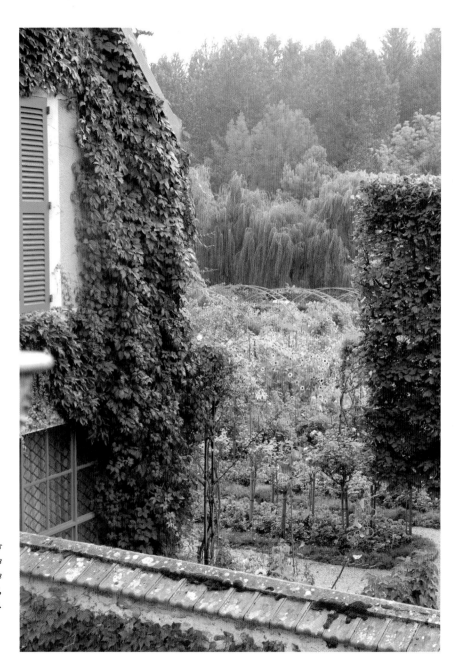

The view of Monet's gardens
from the author's room in
Giverny. Monet's bedroom
window is to the left,
above his first studio.

Twenty-five years since I first visited Monet's Giverny gardens, they are still an essential part of my soul—indeed, I have been making annual visits to photograph them for half my life.

In the fall of 1984, I took ten weeks off from my gardening position in Carmel, California, to travel through ten countries in Europe to visit gardens and museums. When I came to Giverny, I was so touched by the beauty and abundance of the flower compositions, I almost cried. I immediately wanted to know the garden intimately, to know all the flowers in each season, to be there from spring through autumn, digging, pruning, planting, feeding, rejoicing. In short, I had fallen in love.

Determined to make my new dream come true, I set about getting in touch with the conservator of the Musée Claude Monet, M. Gérald van der Kemp. A week later, I was in his Paris office offering my professional gardening skills gratis. He was delighted and, with his wife, Florence, graciously offered me an apartment overlooking the garden and a food allowance in exchange for my work.

I returned to my position as head gardener in Carmel and gave notice to my employers and eight crew members. I packed up my house and returned to Paris to study French eight hours a day while I lived with a French family. Two months of intensive study provided me with a very basic use of the language.

The first month at Giverny was quite challenging, spent proving myself to M. Vahé, the head gardener, and the seven other male gardeners. None of them could understand why an American woman would want to work so hard for free. But my love and enthusiasm for the garden and Monet grew as each new plant came into blossom. We gardened from 8:00 AM to 5:00 PM five days a week. I photographed and wrote before and after work each day. I met wonderful, kind, generous people in the garden. Jean-Marie Toulgouat and his wife, Claire Joyes, relatives of Monet, invited me often to their charming home in the village. There I heard Monet stories, talked about art and gardening, and met other fascinating people. Patricia and Ian Anderson opened their home and lent me a car, which enabled me to discover the delightful Normandy countryside. I met well-known gardeners such as Princess Sturdza, the Mallet family, and Mark Brown, all of whom have exquisite tapestry-like gardens on the Normandy coast. I befriended fellow American artists who pilgrimaged to Giverny to paint, as well as philanthropists who helped fund the garden restoration. Many villagers invited me home for delicious French country cooking and congeniality.

Nine months later, I packed up my treasured memories, worn gardening clothes, and journals and returned to California, my life forever enriched. Now, each time I visit, I continue to be captivated and enchanted by the light and spirit of the place.

I am a gardener and an artist, humbling and gratifying vocations. Since early childhood, I have had a passion for flowers, nature, and art. Gardening is the art that uses

flowers and plants as the paint and the soil and sky as the canvas. Working with nature provides the technique. A successful garden is the highest form of art, requiring one to utilize all the senses while orchestrating plants in various color combinations, shapes, heights, and textures to convey a mood or feeling. The plants are chosen to grow and bloom together harmoniously. The garden canvas is never static but constantly evolving. As seasons progress, the garden develops and reflects the garden artist's design.

Claude Monet was a master gardener, horticulturist, and colorist. He loved nature, flowers, and light, and with each canvas he sought to capture one glorious moment. The Giverny gardens are works of art that long ago inspired him and have continued to inspire countless others ever since. For Monet, the gardens were an alternative world, a place of beauty and restoration from which his visionary paintings came, a vessel to hold different qualities of light and color. Authentic creation awakens our senses and sensibilities, reconnecting us to something greater. Like alchemists, the artist and the gardener transform the ordinary into the extraordinary, in the process expanding and enriching the experience of others, just as Monet's paintings—with their fleeting impressions of light—still move viewers to this day. Georgia O'Keeffe once said: "Nobody sees a flower, really; it is so small it takes time. We haven't time. And to see takes time, like to have a friend takes time." Where O'Keeffe showed us the beauty and intimacy of the world of the flowers, Monet showed us light.

Monet's life and art have shown me that creating beauty and nurturing a garden are not frivolous activities but a direct path to connecting to spirit. It is essential to love the earth, to follow our inner vision, and to take time to introduce each new generation to art and nature. As I continue to garden, paint, photograph, write, and teach, I hope to inspire others to love nature and to be caretakers of our fragile and very beautiful planet. Gardening in balance with nature is a wonderful medium with which to begin.

In this second edition of *Monet's Passion,* I have kept my favorite parts of the first edition, while adding new photographs, garden designs, and ideas. Claude Monet remained my primary muse throughout the process of developing the new material. Nearly blind in his later years, he painted from memory in his studio, first visualizing and then painting his visions. I find it deeply moving that we can create what we can imagine, and that what we create can renew and transform others.

Cultivating beauty nurtures spirit, which blossoms into creativity, rooted and sustained in love.

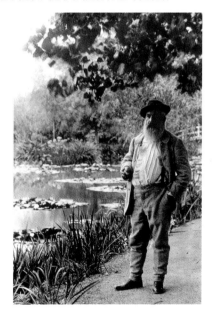

Monet standing beside his water lily pond, 1904.
<small>PHOTOGRAPH BULLOZ, PARIS</small>

Fig. 1. Claude Monet, The Artist's Garden at Giverny, *1900. Oil on canvas. Musée d'Orsay, Paris.*

CHAPTER ONE
THE GARDEN MONET CREATED

---·◆·---

This is where Claude Monet lives, in this never-ending feast for the eyes. It is just the environment one would have imagined for this extraordinary poet of tender light and veiled shapes, for this man who has touched the intangible, expressed the inexpressible, and whose spell over our dreams is the dream that nature so mysteriously enfolds, the dream that so mysteriously permeates the divine light.

—OCTAVE MIRBEAU
"Claude Monet," *L'art dans les deux mondes*, March 7, 1891

Claude Monet created his finest work of art as a living study in light and color, an ever-changing canvas that used his most beloved flowers as his paints. Each plant that grew in this magnificent painter's paradise was thoughtfully placed, just as in an exquisite flower arrangement prepared for a painter's still life. In turn, the gardens that Monet worked on for over forty years became the inspiration for his paintings for the second half of his life.

The gardens at Giverny consist of the Clos Normand garden, featuring nearly three acres of flowers, with its Grande Allée (the flower tunnel with great arches of rambling roses above the broad walk carpeted with creeping, round-leafed nasturtiums), and the two-acre water lily garden with the arching green bridge woven with wisteria. We know these subjects well from Monet's paintings—brilliant Impressionist depictions of nature's moments of full bloom, glorious color, and light preserved on canvas through the hand of the great master.

At the time Monet started painting, most painters began their practice with still lifes in the studio—bowls of fruit or bouquets of flowers—and, when they could afford it, with a model. Landscape painters often sketched various views from nature and then created the finished composition in their studios under controlled conditions.

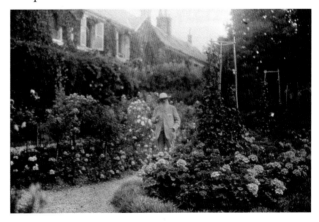

FIG. 2. *Monet in front of his home in Giverny, c. 1923. Autochrome.*
PHOTOGRAPH MUSÉE CLAUDE MONET

The *plein air* Impressionists painted out of doors—directly from nature—and dedicated themselves to capturing the impression of a fleeting moment. They carried their paints (made possible by the recent availability of oil paints in tubes), canvases, and easels through the meadows and orchards and along streams until they came upon an inspirational view. Finding a pleasing composition, perhaps a certain group of trees backlit with the rising sun, they set about painting it as quickly as possible in short, sure strokes of pure color. Monet expanded this concept by composing with nature as he designed, planted, and cultivated his gardens.

Monet came to Giverny at the age of 43 after a series of events drove him to find a place to settle. In 1877 his enthusiastic collector, Ernest Hoschedé, went bankrupt and fled the country in self-exile. His estate was sold for embarrassingly little—barely enough to pay Hoschedé's enormous debts. The art market was flooded with his collection of Monet's and other Impressionists' paintings, sending the prices down. Hoschedé's wife, Alice, and their six children, instantly made poor and homeless, were invited by Monet and his young wife, Camille, to live with them in Vétheuil. The two women took turns wearing their one best dress to go into Paris, where they found work sewing for wealthy ladies; this brought much needed money into the household. In 1878 Camille bore her second son, Michel, but died unexpectedly from tuberculosis a year later; Alice stayed on to help Monet care for his two young sons.

Burdened with financial worries and the responsibility of providing for Alice and eight children, Monet found it almost impossible to paint and was overcome with despair. Desperately he sought a home for all of them. As he was taking a local train to Paris one day, he passed by Giverny and saw an empty pink house. He liked the location of the small, quiet village, the light in the river valley, and the one-hour train ride into Paris. It was close enough to his gallery yet far from the crowds and pressures of the city. In 1883 Monet moved his expanded family to Giverny, having convinced the landlord of the house that he would pay him soon and would in the meantime take excellent care of the property.

Monet told a friend, "I am enraptured. Giverny is the ideal place for me." He was home at last, having found the perfect spot for his large family, and his painting would flourish like the gardens now under his care. He knew this pink stucco house in the country, with its expansive garden and special light, was the place he could finally set down roots. "Once settled, I hope to produce masterpieces, because I like the countryside very much." Monet began selecting and placing plants in ways pleasing to him, establishing a tone and direction for the garden that would become what he described as his "greatest form of art."

The first thing the family did was to plant vegetables for the table and flowers for the spirit. Fortunately for everyone, the family cook had stayed through all their hardships. Delicious food could renew Monet's spirits, and a bad mood due to painting struggles, poor weather, or financial stress would disappear with a taste of one of his favorite dishes, like *tarte Tatin* made using apples from his orchard.

Monet's was a departure from the typical French garden and its highly controlled boxwood hedges,

planted and sheared to create parterres and paisley-like shapes that resembled carpets and embroidery. Traditionally, flowers were used more as color fields than for their individual beauty and form. Even roses had lost favor and were planted only in rarely seen *potagers*. With his eye for color relationships and the effects of light and atmosphere, Monet naturally employed the same principles in his gardens that he used to create his canvases, carefully arranging pure colors in the ever-changing form of flowering plants to create richly patterned textures, moods, and contrasting or harmonizing color relationships. As color only exists because of light, and every shift of light changes our perception of it, Monet was indeed experimenting with living color that changed with every nuance of the day, weather, and season. He planned, planted, and weeded the garden, and in the evening the children watered it, hauling buckets from the well. Gradually the property, with the old apple orchard, the *allée* overburdened with dark evergreen spruce and cypress trees, and the formal clipped boxwood, was transformed.

In 1890, seven years after moving to Giverny, Monet was able to buy the house and gardens. Two years later he married Alice and hired his first professional gardener, M. Felix Breuil, who would remain at Giverny for nearly 30 years. The old house was gradually remodeled to include two guest rooms above the barn (Monet's second studio), a wine cellar, a cheerful yellow dining room, and a large, charming kitchen.

In the dining room, Monet created a welcoming space to spend time with Alice and the children when he was not painting, and to host lunch for friends before touring the gardens. Japanese woodblock prints were hung prominently on the walls and throughout the house, even on the backs of doors. Monet had been an avid collector of the prints since being introduced to them by his friend and fellow painter James McNeill Whistler.

· ◆ ·

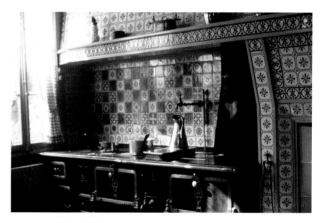

Fig. 3. With lovely blue and white French tile, Monet's kitchen included a large cast-iron stove with several ovens, many burners, and a spigot for hot water. A kitchen door made it easy for fresh produce to be delivered from the vegetable garden and for the cook to bring trays of food outdoors for plein air *dining.*

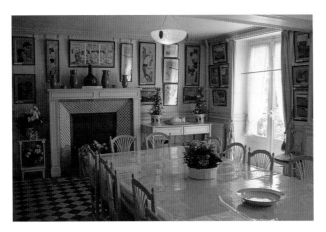

FIG. 4. The cheerful, sunny yellow walls of Monet's dining room warmed even the grayest Normandy day. In Monet's time, it was unusual to paint furniture, but the artist was known for starting new trends. By painting his table, chairs, and armoire in the same two shades of yellow as the walls, and by his use of mirrors, he made the room seem larger. The color scheme also served as the perfect foil for his collection of blue and white china and Japanese woodblock prints. The fireplace, also framed with blue and white tile, gave warmth, while a double set of French doors allowed the daylight to come in.

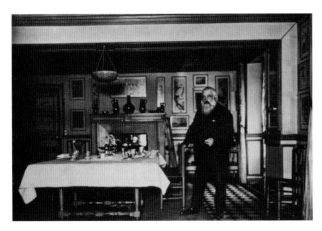

FIG. 5. Monet in his dining room.

With the family settled, gardens flourishing, and his new paintings selling well, Monet was also able to buy the land across a railroad track from the Clos Normand. He convinced the local authorities (after several frustrating tries) to allow him to create a *prise d'eau,* or water intake point, to intermittently divert water from the Ru, a year-round stream that empties into the Epte, a tributary to the Seine. Locals were concerned he would drain too much water and his exotic plants would contaminate their supply, but he eventually prevailed and was able to create his water lily pond.

In designing his water garden, Monet organized the aspects of nature that most intrigued him. The pond became a mirror reflecting each nuance of atmospheric change—a moving cloud, a ripple of wind, a coming storm. It held inverted images of the surrounding landscape while simultaneously supporting hundreds of floating, multifaceted jewels on deep green settings of palette-shaped leaves. The effect was that of a prism spreading shimmering shades of precious gold, ruby, amethyst, sapphire, and topaz over the water's surface. The moving images of light and reflection flickered and changed around the lilies, but they, too, were subjects of the light, which regulated their morning opening and evening closure and added extra sparkle when water droplets caught the passing sun. Inspired by Japanese woodblock prints, Monet built several arched wooden bridges over the Ru that created elliptical reflections in the pond. The largest of them became the main accent of the water garden. He filled the pond with rare aquatic plants, nearly covering the entire surface with carefully placed water lilies of every color. The surrounding

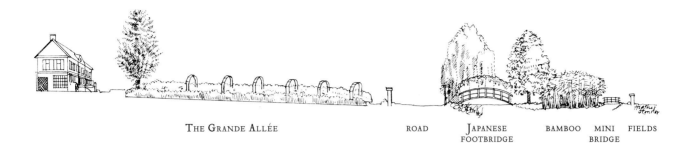

AXIS VIEW OF CLAUDE MONET'S GIVERNY ESTATE

This view of the two disjointed gardens shows how Monet connected them by using a strong axis. The front door of the house lines up with the middle of the Grande Allée, the lower garden gate, and the Japanese footbridge. The axis, about 440 feet in length, runs from the house down the 172-foot-long allée, across the road, and over the bridges to where the gardens end and the pastures begin.

gardens were planted with rare bamboos, ginkgo trees, and flowering Japanese cherry and plum trees. Special lilies ordered from Japan grew alongside more common plants, like the native yellow flag irises that grew in great, tall clumps.

This garden was the inspiration for the artist's *Les Nymphéas,* his water lily series first exhibited in Paris in 1909. As Monet told art critic Roger Marx, "Looking at it, you thought of infinity; you were able to discern in it, as in a microcosm, the presence of the elements and the instability of a universe that changes constantly under our very eyes."

Monet eventually hired five more gardeners to maintain his ever-expanding horticultural vision. One was assigned just to the water garden, while another, Florimond, was in charge of the new kitchen garden. In order to make room for all his flowers and still grow enough to feed the family and guests, Monet bought another two-and-a-half-acre garden with an attached house, known as the Maison Bleue, just down the road. Here, in a geometrical layout with straight paths wide enough for a gardener and wheelbarrow, each vegetable type had its own section, according to old custom. Leaf vegetables—romaine lettuce, spinach, endive, and the red cabbage Monet loved—were in their own beds, separated from root crops like carrots, beets, and potatoes. Brussels sprouts and broccoli were grown in the cooler months in their own area. Lima beans and green beans grew up bamboo tepees. Onions, garlic, leeks, pearl onions, and rocamboles joined herbs like sage, thyme, oregano, chives, tarragon, and rosemary to add important savory flavor to soups, poultry, fish, and game. On the slope with the best sun exposure grew red and yellow cherry tomatoes, chilies and sweet peppers, and artichokes.

Monet was justly proud of his kitchen garden; he even grew the first zucchini in the region. He had tasted it in

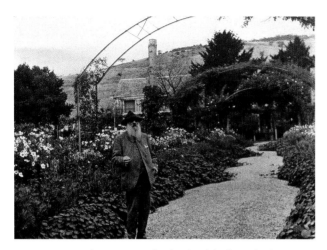

Fig. 7. Monet on the nasturtium-bordered path leading to his house; his last summer, 1926.

his travels to Algiers and sent home seed and planting instructions, as was his custom. Most seeds were started in rows of cold frames, melons and tender seedlings got a head start under dome-shaped glass cloches, and espaliered pear and apple trees grew along sunny walls. Planted where they would not shade the vegetables, plum trees with small yellow fruits were grown beside cherries for tarts and brandied fruit preserves. A few quince and other ornamentals found their way in for cutting and beauty. Florimond would tell Alice what was ready in the garden and then she would make lists of what to harvest, taking into account the preferences of guests; the produce would appear at the kitchen door right after breakfast the following day.

The water gardener was assigned specifically to maintain the pond and keep the water lilies in pristine condition. Grown in submerged tubs, the water lilies bloomed in floating circles, their elegant crown-shaped blossoms displaying the colors that we see in his paintings—pure white, yellow, peach, and bicolored deep pink and crimson. Some tropical blue and purple varieties had to overwinter in tubs of water under benches of orchids in the greenhouse to keep them from freezing. When Monet was working on his series of water lily paintings, the gardener was instructed to come out before dawn in the small flat-bottomed boat to clear the pond surface of any debris, ensuring perfect reflections. He also routinely removed any spent water lily flowers and fed plants monthly to keep them blooming. He even had to clean the flowers when vehicles on the dirt road that divided the gardens kicked up dust onto them; Monet eventually contributed money to the village to pave that section of the road.

In the Clos Normand garden, Monet kept only some of the old fruit trees, replacing them over the years with the Japanese flowering cherries, plums, crab apples, and apricots that provided height and blooms and structure. He and Alice, who loved all trees and didn't like to see any cut, had major arguments over the large evergreen trees that had been planted down the Grande Allée. Monet did a few paintings with them but felt they were too dark and oppressive and took valuable light from his garden. The compromise: the pair of yews nearest the house stayed and the cypresses were taken down. The spruce were limbed up but remained. Monet eventually had them topped as well, feeling they were too out of scale—he grew climbing pillar roses up the trunks and, after Alice died, left them as a tribute to her.

Monet did not like plants with variegated foliage in his gardens, as he was bothered by their busyness and their hybridized look. He preferred solid shades of green for foliage, with the exception of autumn reds and his stunning copper beech by the pond. This beautiful, mature tree was perhaps 100 years old when Monet began his water garden, and he carefully designed around it, creating an island between the Ru and the pond. Although he generally preferred the simple, single-petaled flowers to the more hybridized fancy doubles, Monet used bicolor flowers—such as burgundy cactus dahlias with gold-tipped petals and pale cream peonies tinged with pink in the center—to introduce varied nuances of color in an otherwise monochromatic flower bed. He used these prized flowers with disciplined discretion, placing them with a deliberation equal to that required to place a brushstroke loaded with two colors.

Native plants, such as the local wild scarlet poppies, known as *coquelicots,* which have translucent petals that allow light to stream through, and the handsome mullein (*Verbascum*), with its downy gray-green leaves and tall soft yellow or purple flower spikes, were incorporated into his garden. California poppies (*Eschscholzia californica*) were grown as well and allowed to self-sow, sprinkling their seeds around the garden. He encouraged reseeding of other kinds of poppies, too, in addition to foxglove, pale yellow evening primrose (*Oenothera*), and *Verbascum,* to create surprises when they popped up. Monet found native plants did well with little care, and he also liked their natural, indigenous look and the fact that many attracted butterflies, which he thought of as flying flowers.

Monet once told an interviewer, "Everything I have earned has gone into these gardens, I do not deny that I am proud of them," and he did, indeed, spend all his extra money on extravagant and rare plants, seeds, and bulbs, ordering exotic specimens from all over the world—including his prized lilies and peonies from Japan. He continually experimented with plants, and before introducing a new one to the garden, Monet grew it first in his side nursery garden near the greenhouse and cold frames. After seeing it in bloom and learning more about its particular cultural requirements, he could determine whether the plant was suitable for his garden and if so, exactly where it would be of greatest value. He did not hesitate to move something that did not give the effect he desired. His son Michel and stepson Jean-Pierre Hoschedé also did plant experiments and hybridized their own poppy that they named 'Monet'—an exceptionally large clear red flower that combined a wild strain with a garden variety, a perfect gift for their delighted father.

— ◦ —

Except for some plant orders to nurseries, any specific garden notes Monet may have written about his color themes and specific planting plans have been lost. Fortunately, the gardens were well documented in interviews and articles, as well as in his letters. Many photographs were taken over the years that document the changes over time, including some by Monet, who experimented with photography. It is unclear how extensively he explored the medium, but he had a darkroom in the garage, and family members said that he occasionally worked there on days when he couldn't paint. Photography provided Impressionist painters with a new way of seeing, allowing these artists to

capture movement and frame a moment in time, just as in their artwork. Photographs were also a great reference, recording compositions and light patterns for the painter to reproduce back in the studio.

The artist continually experimented with color and texture to convey the nuances of natural light in his paintings as well as in his living garden canvases. "I am following Nature without being able to grasp her," Monet once said. "I perhaps owe having become a painter to flowers." From his Japanese prints he had learned—as had many of his fellow Impressionists—valuable lessons about using pure color (*tons clairs*) and the juxtaposition of shapes to create forms, and in both his paintings and his gardens he used contrasts and relationships of colors to do the same.

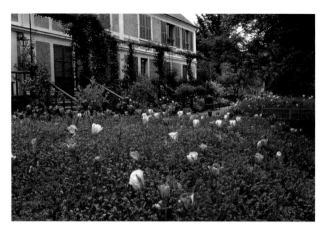

Fig. 8. Tulips provide an example of how Monet staged his plantings according to various color schemes and contrasted the colors of the flowers.

Monet organized different areas of the gardens utilizing various color schemes—he would often hold cut flowers in his hand to see how they worked together in the light—and he arranged the many small, rectangular flower beds like swatches of paint on his palette. Monet fully understood the complexities of color, and in a sophisticated manner he sought to simplify color relationships to create a diverse yet integrated result. In some areas he planted monochromatic masses, color zones like the three-foot-wide flower beds of solid lavender purple *Iris germanica*. In another area, monochromatic flowers would range in value from pure white to soft pink, or vibrant red to the deepest shades of crimson, all placed together to create a tonal structure. He also contrasted primary colors, like intense red tulips set against cool blue forget-me-nots, which seen from a distance became a violet color zone, as in a pointillist

painting. Blue with clear yellow was one of Monet's favorite color combinations—he would plant reflex yellow tulips to emerge from a carpet of sky-colored bluebells or forget-me-nots. He even designed china in yellow, blue, and white to be used for special occasions in his blue-accented yellow dining room.

Another color relationship Monet used, not only in some of his paintings of the south of France but also in the cool climate of his Giverny gardens, was background shades of pastel pink and green with a foreground of stronger reds and greens. He planted island flower beds in front of his Mediterranean-style house with its viridian shutters. One contained deep pink and red geraniums, with red nasturtiums on 3-foot bamboo tripods and an edging of silver gray pinks (*Dianthus*). The bed closer to the house was planted in pink geraniums with standard pink and white roses rising above them, intentionally

repeating the dominant house colors to create a unity of composition in the garden.

The Clos Normand garden, which served primarily as Monet's experiment with living color, required a structural framework to support such a complicated color palette, and he used a gridlike layout of rectangular beds together with iron trellises, arches, and *tuteurs* to fashion the higher plane of the garden, bringing color upward. To unite the whole composition, Monet chose a dominant color that he would interweave throughout the garden. Large masses or sweeps of the same color family gave more impact and provided the drama he desired. This also made it possible to weave many colors together and have them complement one another when viewed from different parts of the garden. Sequences of small accents of blue, lavender, or gold were interknit within the flower scheme as highlights of color to catch the light. Color sequences varied with the progression of each season, accentuating the changes in light and weather. The interplay of delicate to strong color contrasts keynoted the floral compositions, breaking the uniformity of the garden grid, while the abundant informal edging plants, like aubrieta, saxifrage, and nasturtium, crept out into the gravel paths, softening the straight lines of the flower beds.

Monet planted rich orange, gold, and bronze wallflowers together with pink tulips on the west side of the flower garden to amplify the effects of the setting sun. Elsewhere he used clear blue and delicate salmon hues to convey the feeling of mist softening the morning light. Pastel hues in the distance, with bright, crisper values of the same color in the foreground, added a painterly illusion of a misty background.

Luminosity was as important in Monet's gardens as it was in his paintings. He was as keenly observant of the effects of light shining through the petals of an iris or poppy and the reflections of the sky and surrounding landscape in his water lily pond (see figures 9 and 10) as he was of the light illuminating the textures of a building, as seen in his series of Rouen Cathedral paintings. Through vistas he cut into his bamboo grove, he observed how light and shadow patterns played together and added animation to the garden. Monet understood the magical ability of light to soften or dazzle color. He used subtle hue changes in the shades of green foliage plants he combined to create even more contrast between lit and shadowed leaves. From the spring hues of yellow-green willow leaves and a bright green lawn to the crisp, dark, reflective hollies and soft blue-green iris foliage, he blended leaf shape, texture, size, and surface sheen to enhance the effects of light.

• ◆ •

Monet's gardens were never designed with spectacular berries, grasses, or tree bark for winter interest. Instead, all the trellises with dormant roses, the pair of evergreen yew trees in front of the house, and the paths provided structure and revealed the bones of the landscape. Even in harsh winters when the pond froze, the bridge and massive trees provided a stark, severe beauty. Monet occasionally traveled in winter to paint in places such as Venice, southern France, London, or Norway, where the local winterscapes often would captivate his interest. When the Seine froze over and huge blocks of salmon and blue ice floated over its silver surface, Monet, who

respected each season and its particular shifting light and atmospheric changes, painted furiously in the freezing cold along the riverbank. Although he planted early blooming bulbs, when he craved flowers in wintertime, he visited his greenhouse to enjoy his orchid and fern collections and, like many gardeners, he pored over the latest seed and bulb catalogs.

Spring was a time of riotous, luxuriant color in the gardens. St. Valentine's Day was occasionally greeted with precocious little white snowdrops, purple and gold crocuses, violets, and masses of bluebells, all harbingers of spring. Later, poet's narcissus, with their stark white petals and red-rimmed golden cups, bloomed in naturalized drifts throughout the lawns. Grass was minimal—simply a place to plant bulbs, poppies, and blooming trees and roses, or to use as a carpet or frame. Bright yellow winter jasmine cheered up corners of the flower garden and was cut along with golden 'King Alfred' daffodils for sunny indoor arrangements. Monet usually planted simple, clear colors, but with early spring tulips he went wild with color: Darwin tulips in pinks and mauve and every color but blue bloomed on

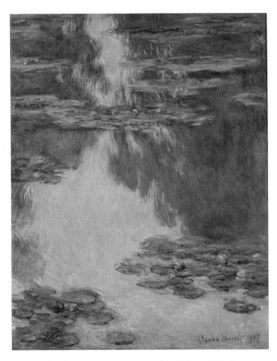

Fig. 9. Claude Monet, Les Nymphéas (Water Lilies), 1907. Oil on canvas. Bridgestone Museum of Art, Tokyo.

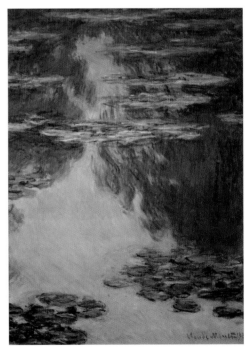

Fig. 10. Claude Monet, Les Nymphéas (Water Lilies), 1907. Oil on canvas. Collection of Terua Akai.

two-and-a-half-foot stems; parrot tulips in yellow and red were planted for their unusual fringed petals and twisted shapes; clear yellow retroflex tulips that resemble the French fleur-de-lis grew alongside bluebells or blue forget-me-nots; and red Rembrandt tulips (popular subjects in seventeenth-century Dutch flower paintings), with their striped and mottled petals in such contrasting colors as yellow and red, were used as brilliant color spots. Planted over the bulbs in complementary colors were pansies with their little faces, long-lived English primroses, sweet-scented wallflowers in golds, oranges, and rust, crowns of pink or blue columbine, and spice-scented stock, all blooming in great masses of molten colors within lavender frames of aubrieta. Unhybridized *Clematis montana,* with its profuse sprays of white flowers blushed with rose or azure, were trained to hang in loose, casual garlands from light-gauge metal structures that outlined the sky. The lacy flowers were left to move freely in the wind, uniting the many small, multicolored, paint box–like flower beds below and giving the impression of lace curtains blowing in the breeze.

Monet coordinated floral compositions to complement the blooming of the pink or white blossoms of apple, cherry, and plum trees. Golden chain trees brought sunshine into the mist-filled garden, and the mauve colors of standard wisteria and lilacs blended with the pinks and whites of flowering trees and bulbs. All contributed to the enchantment of Monet's floral world, and many visitors remarked it was like a fairyland, with blossoms above, below, and completely surrounding them in the delightfully scented soft light.

By May and June there was no holding back the

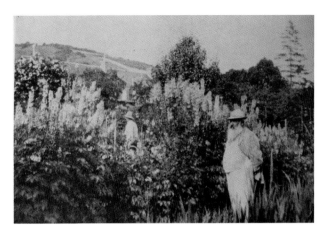

Fig. 11. *Monet in the flower garden of his home. Reproduced from an article by Royal Cortissoz, "The Field of Art; Claude Monet," published in* Scribner's Magazine, *March 1927.*

rampage of late spring color. The mauve bearded irises bloomed in three-foot-wide beds of solid color. Standard lilacs were planted down the centers of the beds, bringing the same color upward. Huge, crinkled Oriental poppies in bright vermilion, soft coral pink, and dusty mauve, with large, velvety black splotches in their centers, bloomed profusely in splashy clumps throughout the lawns. Prized herbaceous and tree peonies grew in the large mixed perennial borders and along the banks of the water lily pond. With both varieties, Monet preferred the less common single-flowered Japanese variety that produced flowers up to twelve inches across. The silky colors ranged from pure white to creamy yellow and pink to red, with the tree peonies adding shades of lavender and purple.

About the time the peonies, irises, and Oriental poppies were in their full glory, the roses—mainstays

of the garden—began to bloom. Monet had hundreds of magnificent roses in a myriad of colors and forms. Although he favored the simple, wild-looking single roses like those found along country hedgerows, he grew all types. Pink and white standard roses bloomed in the island beds near his house. Iron arches covered with climbing roses framed the Grande Allée. Multiflora rose standards were trained on six-foot-tall umbrella-like supports, creating romantic bouquets above the flower carpets. Old-fashioned shrub roses, with their heavenly scents, rich colors, and deep green foliage, were planted in solid masses between the pillar roses to frame a lawn and provide the background for the richly colored perennial flower borders. The climbing rose *la belle Vichyssoise,* which grows 21 to 24 feet high with long clusters of small, highly scented blossoms, grew up existing tree trunks and over trellises along the pond, adding to the magnificent medley of textures and colors. A multitude of focal points throughout the garden provided little vignettes to delight the eye and offer motifs to paint.

On a 20-foot-long trellis below his second-story bedroom window, Monet grew his favorite rose, 'Mermaid', which boasted single clear yellow flowers with delicate deep gold stamens. He preferred cheerful color harmonies and would combine pink, yellow, and coral-salmon roses underplanted with mauve to echo the colors of a dawn sky, or red and pink with white. As spring matured into summer, thousands of flowers of one variety might bloom at once, forming color zones of white, pink, rose, or lavender. It might start with three-foot-high penstemon (*P. gloxinioides*) or stock (*Matthiola*). Later came red *Phlox paniculata,* reaching three feet or more. Taller yet, spikes of hollyhocks (*Alcea rosea*) in soft pastels and foxgloves (*Digitalis*) in deep rich mauves, pinks, and spotted white bloomed near large beds of delphinium—in every shade of blue from baby blue to deep midnight—that sent spires of color six feet into the air. Tall, small-flowered gladioli were planted in rectangular beds as well as in pots. Monet grouped large numbers of tall flowers to catch the light, and he enjoyed being able to walk among them and look directly into the blooms.

Monet liked to plant flowers in drifts, with sprinkles of yellow for a sparkle of light and clear cool blues or violets to contrast the warmer shades. Wild-looking leopard's bane (*Doronicum sp.*), with its clear yellow daisylike blossom, bloomed in the garden from early spring to autumn, adding a cheerful sparkle. Mauve aubrieta and periwinkle blue campanula unified the beds and provided contrast. Free-flowering, clove-scented old-fashioned cottage pinks (*Dianthus plumarius*) edged beds with sprawling informality. Flame-colored nasturtiums (*Tropaeolum majus*), with their round yellow-green leaves, crept along the Grande Allée, etching a zigzag walking path and completing the tunnel effect begun with the rose-covered arches overhead. Cactus dahlias, with their fluted petals sometimes edged in gold and their centers of shimmering coral or delicate lavender, bloomed in wide beds in every bright color and subtle shade available. Monet always purchased the latest varieties of tubers available from Étoile de Digoin, a leading dahlia breeder, trading some with his friend Gustave Caillebotte for wild orchids, a new fern, or some other specimen he had eyed.

By September, gold, burnt orange, and shades of lavender and purple dominated the rampantly growing garden. Goldenrod, with its fuzzy soft tassels, and *Helianthus,* the gold daisylike sunflower, produced thousands of flowers in six-foot-tall masses. White Japanese anemones (*Anemone elegans*) and single old-fashioned gladioli took over beds in wild, elegant abandon. Snapdragons and china asters—perfect for cutting—grew in an orderly profusion of pastel rainbows. Large swatches of rich blues, purples, violets, and deep ruby pinks provided by the invaluable perennial asters (*A. frikartii* and *A. novibelgii*) were woven through the golden tones, completing the lavish autumn tapestry. All these plants have great height, so the entire plane of the garden horizon ascended to meet the trellised roses, fruiting trees, and the house and third studio, which by this time were clothed with the reds and oranges of Boston ivy.

Every year in Giverny, Monet's glorious gardens put on a spectacular four-act play, each season staging its own distinctive performance and bringing its unique drama to those fortunate enough to experience it. It is no wonder that Monet's desire was "to continue always this way, in a quiet corner of nature."

• ◆ •

Over the years Monet poured time, resources, and his artistic vision into his gardens. Under his creative guidance, the flower gardens and water lily pond matured, and through his experiments with arranging nature, he became more intimately familiar with her secrets. Everything he desired was within his garden walls—it was the sanctuary that held and nurtured his spirit through difficult times, and it was the living

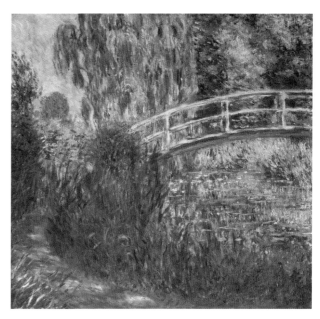

Fig. 12. Claude Monet, The Japanese Bridge in the Garden of Giverny, *1900. Oil on canvas. Christie's, London.*
© CHRISTIE'S IMAGES LTD. / ARTOTHEK, MUNICH

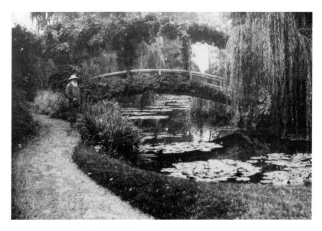

FIG. 13. *Monet by the Japanese bridge.*
PHOTOGRAPH H. ROGER-VIOLLET, PARIS

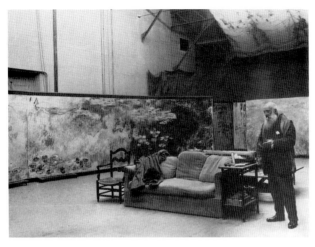

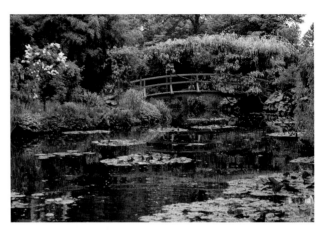

Fig. 14. Monet posing in front of his huge water lily paintings in his third and final studio at Giverny, c. 1922.

Fig. 15A. This photograph shows Monet's flowering bridge as it appears to someone with normal vision.

Fig. 15B. This is how the bridge might have appeared to Monet around 1918, when his cataracts were in their early stages and his vision was 20/100. Most colors are still distinguishable, but a yellowish cast and loss of subtle color distinctions caused the painter more difficulty than the blurred images. "My bad sight means that I see everything through a mist," Monet wrote. "Even so it is beautiful, and that's what I would like to show."

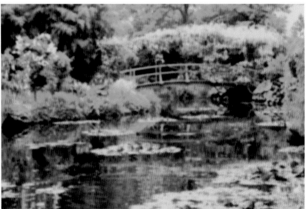

Fig. 15C. This photograph shows how the bridge would have looked when Monet's vision had worsened to 20/200. His vision was darkening, there was very little color nuance, and images were more blurred. In the summer of 1922 he was almost blind and could only see an indistinct fog of dark yellows and greens. He had three procedures on his right eye; the third, in 1923, proved successful. Monet could see again and resumed painting with vigor.

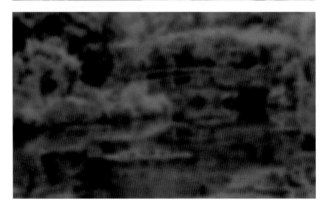

Figs. 15B and 15C are Photoshop simulations of Monet's vision prepared by Dr. Michael Marmor, Department of Ophthalmology, Stanford University School of Medicine

studio that provided him with endless inspiration for his art. He said that all he had to do was turn his head for another motif or wait a few moments for a new sense of light. Always working quickly to capture the fleeting impression, he kept stacks of canvases ready to go whenever the light changed.

A difficult decade for the painter began in 1911 with the death of his beloved Alice, followed by the challenges of failing vision, the loss of his eldest son, Jean, and the outbreak of war in Europe. Yet during this time, Monet began the ambitious project of painting large mural studies of his water lilies, a collection he would later give to his country in a gesture of love he called his "Bouquet to France." Monet envisioned these water lily paintings as helping to restore the soul of his war-torn country, and he hoped they would bring peace and beauty to those who viewed them.

In 1912, nearly thirty years after Monet settled in Giverny, his eyesight began to falter. Cataracts were beginning to blur his vision and muddy his perception of colors. Although he continued to paint, employing by long habit the colors he had unvaryingly used in the past, he no longer could trust what he saw—everything appeared as if in a mist. By 1923 Monet, now nearly blind, was convinced by friend Georges Clemenceau to undergo cataract surgery. The successful operation on his right eye restored his sight and he could again see colors. He continued to paint with vigor during the last few years of his life, living long enough to complete the water lily murals, his greatest legacy.

Inextricably linked to his gardens and his art, Monet was challenged over his long life by health difficulties, hardships, and heartbreaking experiences that could have shattered a lesser person's spirit. Yet he persevered. During the decades he spent studying light, he developed an intimate relationship with nature and her laws, which imbued him with faith and fortitude as well as a deep knowledge of the healing power of beauty. Years spent as a gardener and painter cultivated his passion and courage to render what he witnessed onto canvas—images he hoped would open the hearts and transform the lives of countless viewers for centuries to come.

Like his humble habit of digging in the soil, planting seeds, and tending his beloved water lilies, he held on to a vision that he cultivated in the best of times and the most tragic. He endured, and his art and gardens flourish and inspire us to this day as a living reminder of the power of nature, beauty, and creativity.

Fig. 16. Claude Monet, The White Water Lilies, *1899. Oil on canvas. The Pushkin Museum of Fine Arts, Moscow, Russia.*

The Clos Normand
Flower Garden

1 ROSE TREES AND ESPALIERED PEARS ALONG THE WALL, GATE TO ROAD

2 MONET'S SECOND STUDIO

3 GREENHOUSE FOR ORCHIDS

4 COLD FRAMES FOR SEEDLINGS

5 GROWING FIELDS FOR NEW PLANTS

6 STEPS TO UNDERGROUND PASSAGE LEADING TO WATER LILY POND

7 LINDEN TREES WHERE MONET'S FAMILY PICNICKED

8 SPRING PLANTING OF WALL-FLOWERS UNDER APPLE, CHERRY, AND PLUM TREES

9 LILAC TREES

10 CHERRY TREES

11 SHRUB AND PILLAR ROSES ON 10-FOOT COLUMNS

12 PERENNIAL BORDER WITH IRISES AND ROSES

13 TAMARIX TREE

14 ISLAND BED WITH ROSE TREES, COTTAGE PINKS, AND TULIPS WITH FORGET-ME-NOTS

15 PILLAR ROSES WITH MONOCHROMATIC FLOWERS

16 LAWN WITH PLANTINGS OF IRISES AND ORIENTAL POPPIES

17 MONET'S HOUSE, 104 FEET LONG BY 20 FEET DEEP

18 SPRUCE TREES

19 GRANDE ALLÉE (172 FEET LONG BY 22 FEET WIDE BETWEEN ARCHES)

20 GATE MONET PASSED THROUGH TO GO TO THE JAPANESE FOOTBRIDGE

21 JAPANESE FLOWERING CRAB APPLES UNDERPLANTED WITH YELLOW WALLFLOWERS IN SPRING

22 "PAINT BOX" FLOWER BEDS (6 BY 13 FEET)

23 CLEMATIS ARBORS OVER FLOWER BEDS

24 WHITE TURKEY YARD

25 ESPALIERED APPLE TREES

26 MONOCHROME PERENNIAL BEDS

27 SMOKE TREE

28 PERENNIAL BEDS

29 STANDARD ROSES

30 ENTRANCE BUILDING FOR VISITORS

31 MONET'S THIRD STUDIO (ATELIER AUX NYMPHÉAS)

32 CHICKEN YARD

33 PRIVATE RESIDENCE

34 ESPALIERED APPLE TREES

35 PINE TREE

36 GREEN BENCHES

37 PATH FOR VISITORS (INDICATED BY DARKER COLOR IN ILLUSTRATION)

Garden dimensions: 380 x 240 feet

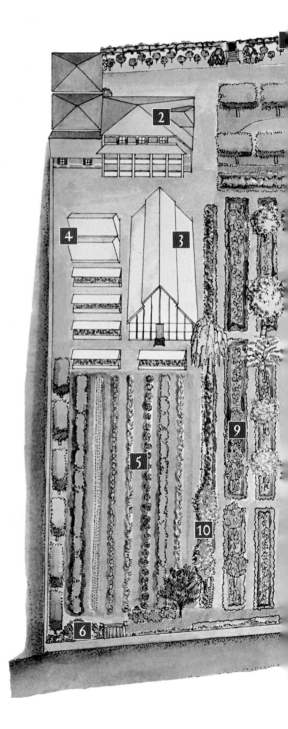

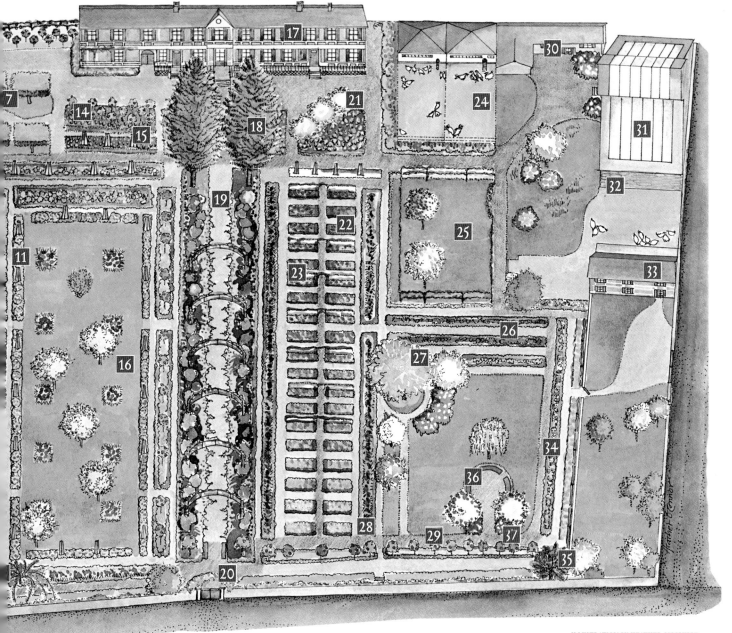

ILLUSTRATION BY HEATHER O'CONNOR

The Water Garden

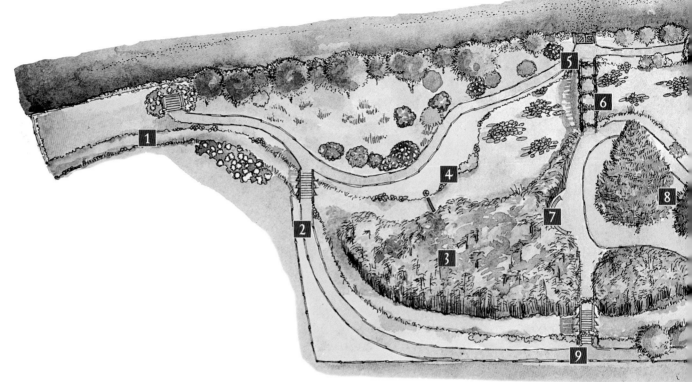

ILLUSTRATION BY HEATHER O'CONNOR

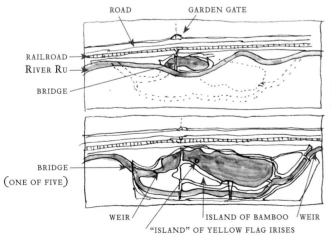

ROAD GARDEN GATE

RAILROAD
RIVER RU

BRIDGE

BRIDGE
(ONE OF FIVE)

WEIR ISLAND OF BAMBOO WEIR
"ISLAND" OF YELLOW FLAG IRISES

BASED ON A DRAWING MONET CREATED IN 1892, PLAN SHOWS HOW THE POND ORIGINALLY APPEARED.

IN 1901 MONET PURCHASED THE LAND SOUTH OF THE RU TO CREATE HIS WATER GARDEN. MONET TRIPLED THE SIZE OF THE POND BY REROUTING THE RU, ADDING TWO WEIRS TO REGULATE THE WATERS AND BUILDING FOUR BRIDGES.

Drawings adapted from Claude Monet, 1840–1926, *by Charles F. Stuckey (see page 126).*

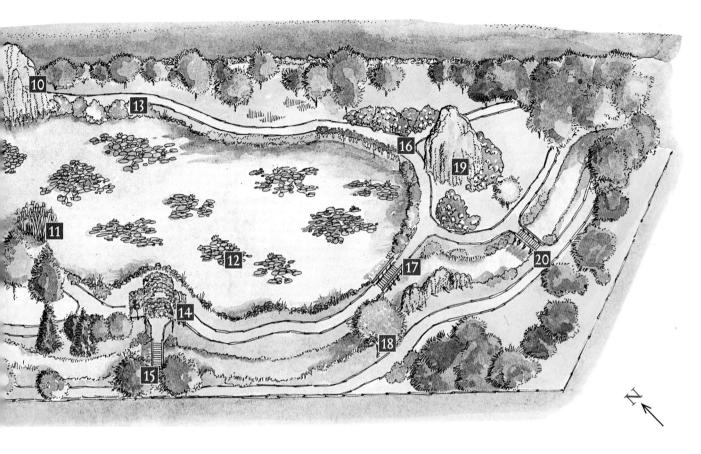

1 STEPS TO UNDERGROUND PASSAGE LEADING TO
 FLOWER GARDEN
2 SMALL BRIDGE OVER THE RU, LEADING TO THE BACK
 OF THE GARDEN
3 BAMBOO GROVE
4 WEIR WHERE POND WATER IS LET OUT
5 GATE MONET PASSED THROUGH TO GET TO THE
 GRANDE ALLÉE
6 JAPANESE FOOTBRIDGE WITH WISTERIA ARBOR
 (18-FOOT SPAN)
7 ROUND STONE BENCHES
8 COPPER BEECH TREE
9 SMALL BRIDGE WITH ROSE ARCH

10 OLD WEEPING WILLOW TREE
11 YELLOW WATER IRISES (12 X 12-FOOT ISLAND PLANTING)
12 WATER LILIES
13 AZALEAS
14 ROSE ARCHES OVER A BENCH; BOAT DOCK AREA
15 SMALL BRIDGE
16 WISTERIA ARBOR (6 FEET HIGH; 34½ FEET LONG)
17 BRIDGE OVER WEIR WHERE FRESH WATER ENTERS
18 JAPANESE CHERRY TREE
19 WEEPING WILLOW TREE
20 BRIDGE

Garden dimensions: 418 x 153 feet

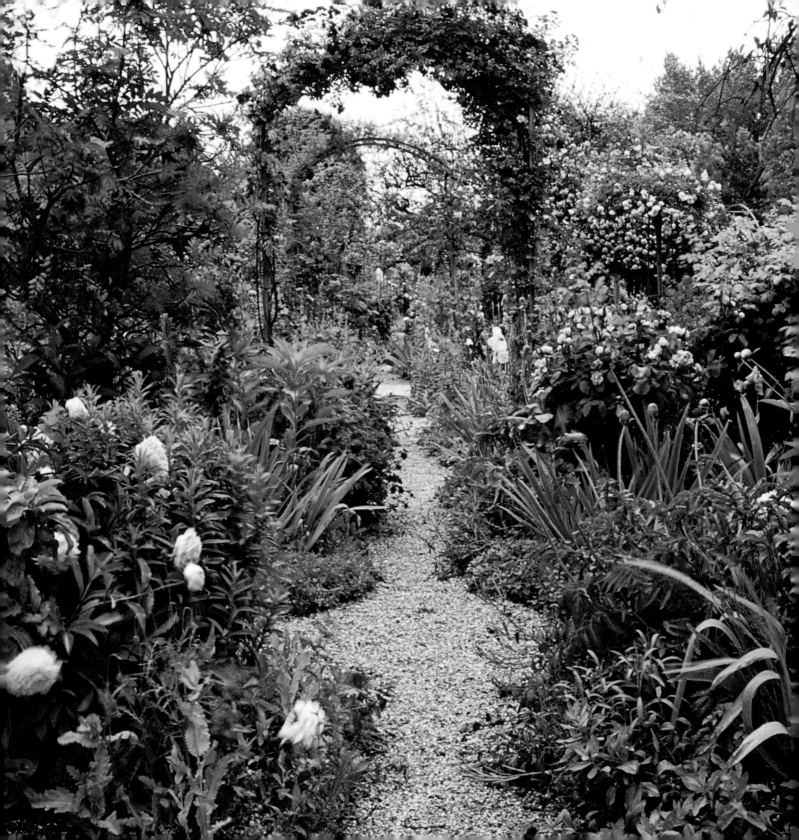

Chapter Two

MONET'S GARDEN TODAY

—•◆•—

If I can someday see M. Claude Monet's garden, I feel sure that I shall see something that is not so much a garden of flowers as of colors and tones, less an old-fashioned flower garden than a color garden, so to speak, one that achieves an effect not entirely nature's, because it was planted so that only the flowers with matching colors will bloom at the same time, harmonized in an infinite stretch of blue or pink.

— MARCEL PROUST
"Splendors," *Le Figaro,* June 15, 1907

Monet's charming house of crushed pink brick is nestled tranquilly among green trees. The river valley spreads beyond his garden boundaries to the lush farmlands, picturesque meadows, and the shimmering light along the Seine River. This countryside enchanted Monet. He traveled in a little studio boat to capture on canvas the fleeting mist at sunrise along the riverbank, or a red field of dazzling poppies on the hillside.

OPPOSITE: Two metal arches covered with roses connect flower beds and frame views, beckoning the garden visitor. An arch over a gate creates a welcoming entrance.

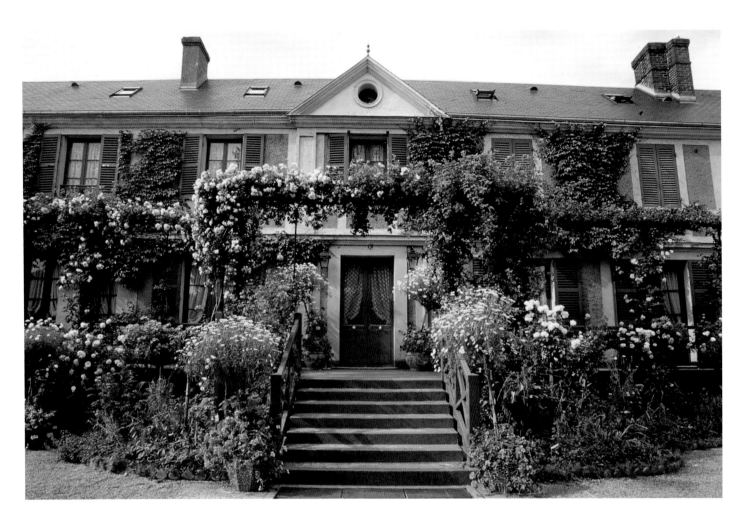

Monet installed an iron trellis along the front of his house and trained rambling roses to climb across the entire face of the house. Today, as then, every doorway is festooned with roses so that perfumed air can drift into every room. Boston ivy (*Parthenocissus tricuspidata*), a deciduous vine, is encouraged to attach itself to the stucco to further obscure the structure and make it a living part of the garden. Flower beds in front of the house are brimming with bulbs, annuals, perennials, and vines. Blue and white Chinese jardinières featuring standard daisies serve as accents to the porch and stairway.

The result is a charming entrance to Monet's home. For instructions on how to create your own blooming house, see pages 88–91.

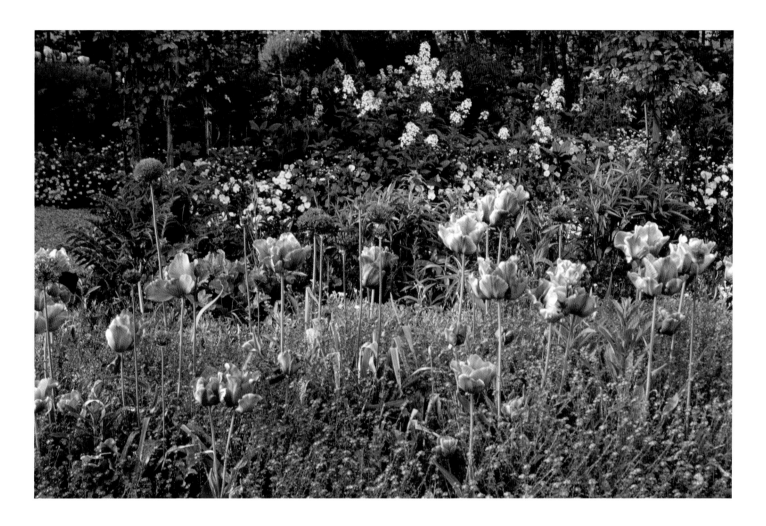

Monet was a keen observer of light and of how a color was perceived in association with other colors, and he was constantly conducting color experiments with his paints as well as with plants. Pointillists such as Seurat applied tiny dots of pure color to their canvases—for example, blue and red—and allowed the viewer's eye to mix them, rather than pre-mixing the color purple; in this way a vibration was created on the canvas. In the spring, Monet's bulb plantings often had a similar effect. You can create a similar relationship of colors in your own garden by coordinating the colors of the bulbs with those of a bed of annuals.

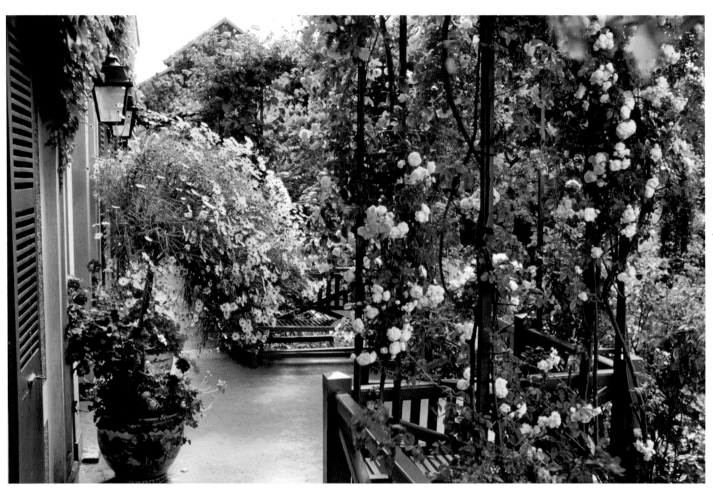

A porch runs the whole length of the house, except for the north end where Monet had his first studio. Rose arbors form a delightful curtain across the front, and two built-in benches frame the front door. From nearly every room, French doors open onto this space. Raised four to six feet above the garden level, the porch was a lovely place to survey the garden and enjoy a cup of afternoon tea.

Introduced in 1918, 'Mermaid', a clear yellow single-petaled climbing rose, became a favorite of Monet's. He planted it beneath his second-story bedroom window.

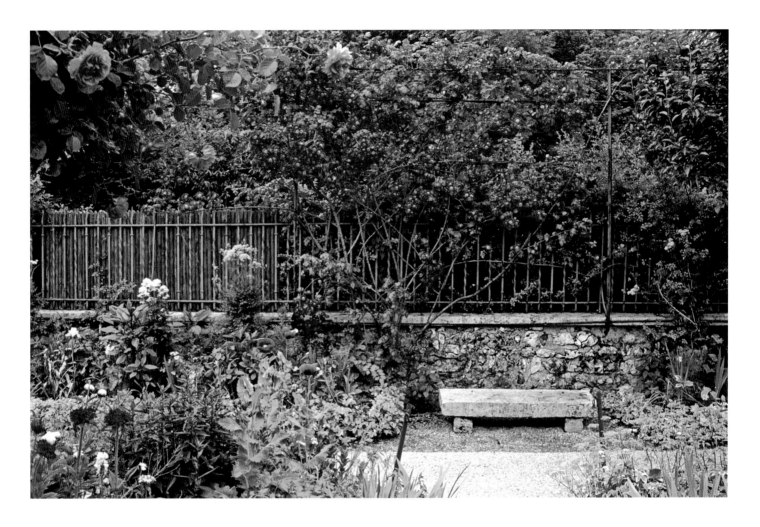

Originally Monet's garden was bordered by a high stone wall, but he decided to lower it to allow people who walked past to enjoy the beauty of his garden. Climbing roses now create a blooming enclosure, and an old stone bench invites a moment of contemplation.

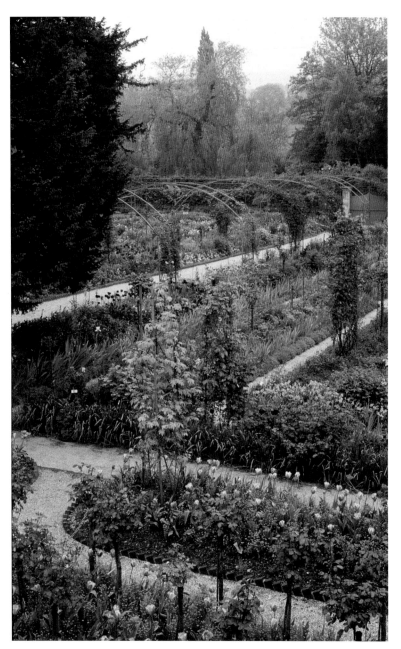

Monet's Clos Normand flower garden is framed by a series of narrow pale pink gravel paths that delineate the garden beds and give gardeners access for planting and care. The paths form a grid containing raised flower beds and lawns filled with flowering bulbs, roses, and fruit trees. From Monet's second-story bedroom window, he could survey most of his blooming artwork. The early spring is a wonderful time to see the orderly geometric layout of the gardens and enjoy the abundance of spring bulbs. One can also observe the creative use of structures for climbing roses and vines, and the zigzag pattern of the on-edge bricks that define some of the raised beds.

Monet's gardens, imbued with the spirit of the master, continue to inspire painters from all over the world. Mondays the garden is closed to visitors so that the gardeners can take care of bigger projects. On these days, artists, by arrangement, are allowed into the garden to paint. It is often challenging, with foggy damp mornings and frequent rain, but the spirit of Monet persists, and artists come as on a spiritual pilgrimage, taking home a deep sense of what it must have been like to live surrounded by such beauty.

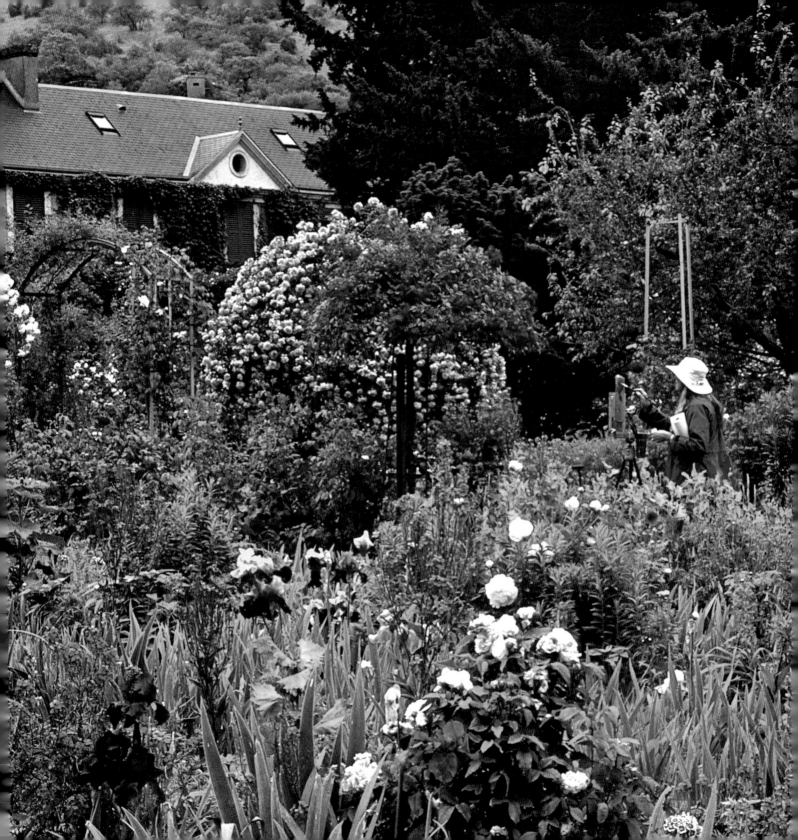

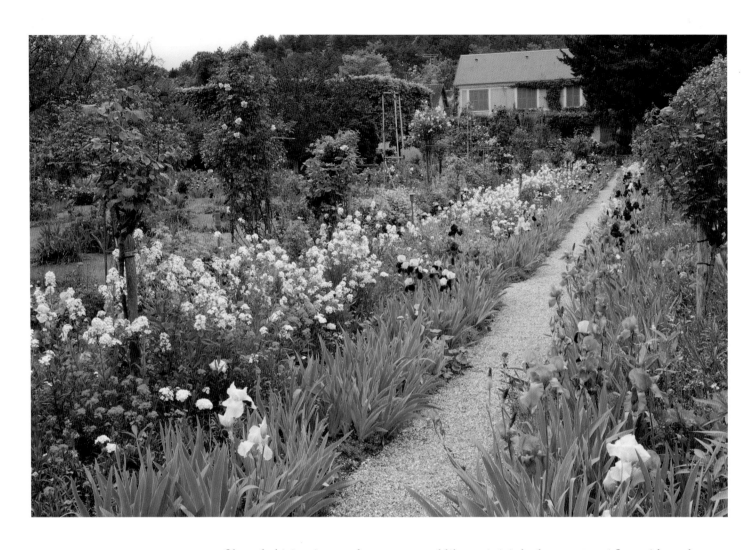

Monet grew great masses of bearded irises in purple, mauve, and lilac. His iris beds were 3 to 5 feet wide and up to 100 feet long, with narrow gravel paths between for the gardeners to tend the magnificent blooms. Monet, who did a series of paintings of his irises, once wrote to a friend, "Come Tuesday. The irises will be at their height." Indeed these cherished flowers last longer in memory than in the actual garden.

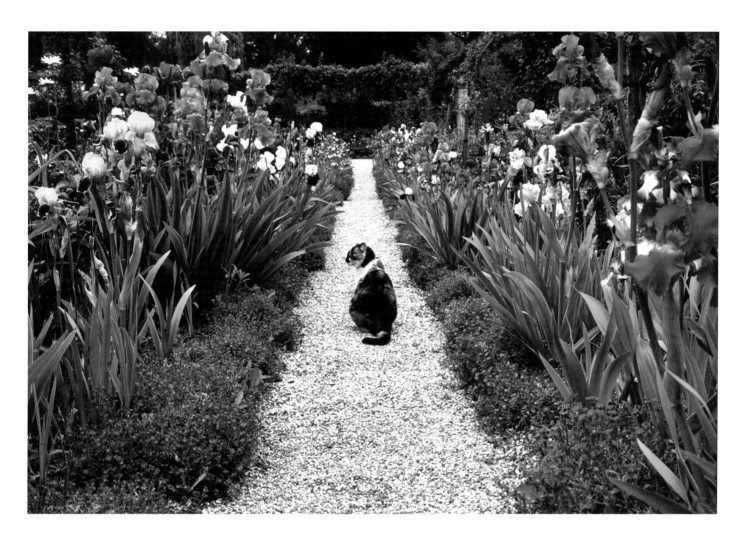

One of the original cats to reside in the restored garden, Fifi poses among the irises that line this narrow
path edged with mauve aubrieta (*A. deltoidea*), a perfect edging to complement the irises, and one
used to edge most of the borders as a unifying theme throughout the flower garden. A cat in
the garden adds playfulness and charm. Fifi earned her keep by mousing,
while the bell on her collar warned birds to keep their distance.

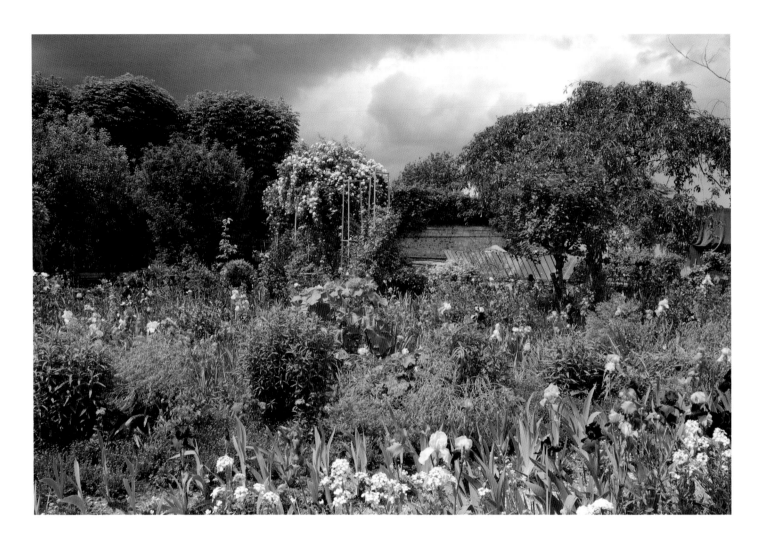

The light in Giverny is constantly changing, and between storms the dramatic light could inspire Monet to paint quickly under an umbrella. In between rainstorms, every flower is shiny and reflects the emerging light. The silver gray rain clouds and blackened sky become a theatrical backdrop to the garden drama. It is as though every blooming plant has a spotlight on it. Monet would go to great lengths to capture these fleeting moments on canvas. He lived for the beauty of the light, its ever-changing effects, and the challenge of painting an impression of it quickly.

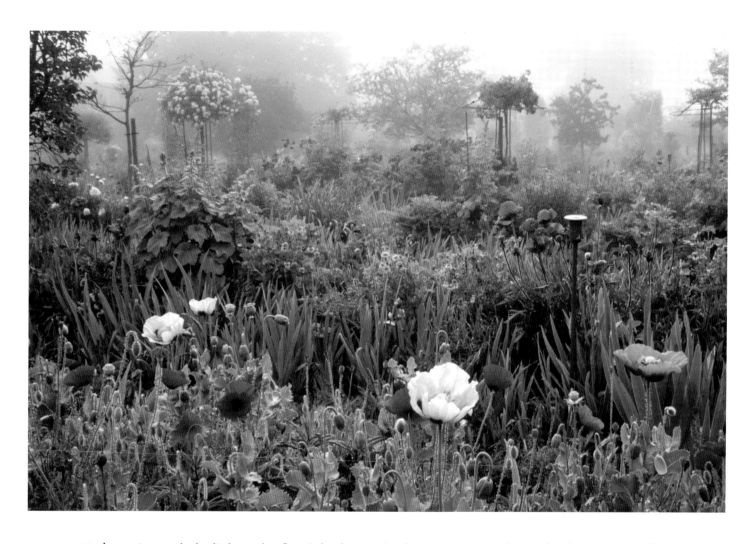

Red poppies catch the light and reflect it back, even in the mist. Because the garden is in a river valley surrounded by hills, mist forms over the nearby Seine and transforms Giverny into a fairyland. Monet sought to capture this misty light in his paintings, rising at 4 AM to witness the early morning display.

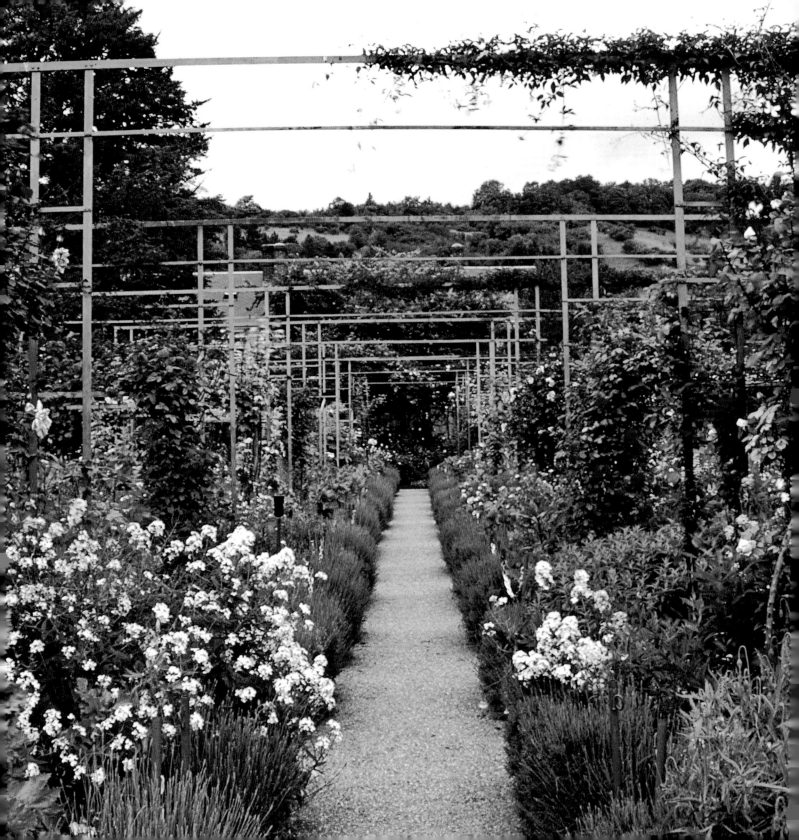

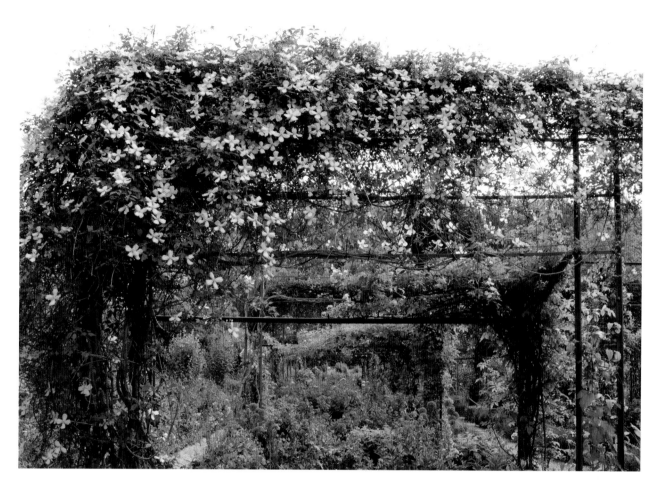

Graceful garlands of unhybridized *Clematis montana,* with their profuse sprays of white flowers blushed with rose or azure, were trained to hang loosely across these open, airy, rectangular arbors. Described by Monet's visitors as "looking like lace curtains blowing in the wind," these flowers were allowed to move freely in the breeze high above the garden path, where they united the many small multicolor flower beds with their paint box–like colors. Today, both roses and clematis grow on these arbors. Fragrant lavender is planted at the base of each paint box flower bed, which encourages visitors to run their hands across the blooms for a scent that relaxes and soothes. To learn how to make your own paint box garden, see pages 96–101.

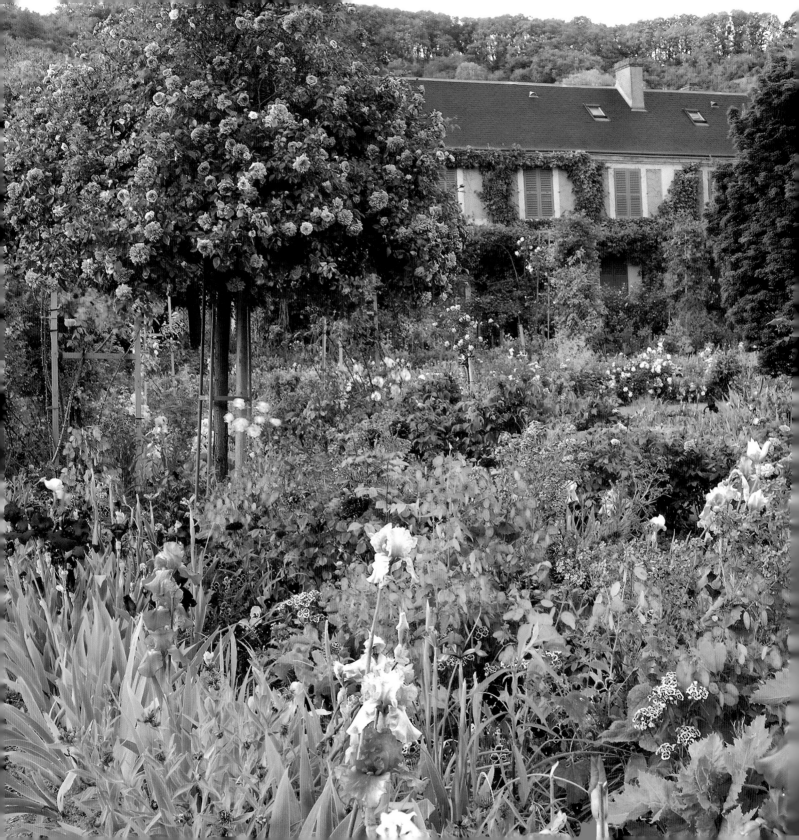

Romantic drifts of shell pink peonies, sky blue irises, and lavender dame's rockets (*Hesperis matronalis*) surround the queen of the garden—a stunning bouquet of pink roses that rises like a cloud above all the other flowers. There is a certain moment in May when the bearded irises are still in flower, the peonies appear, and the roses start blooming, and all are woven into this celebratory spring tapestry. This is the garden in its full magnificence!

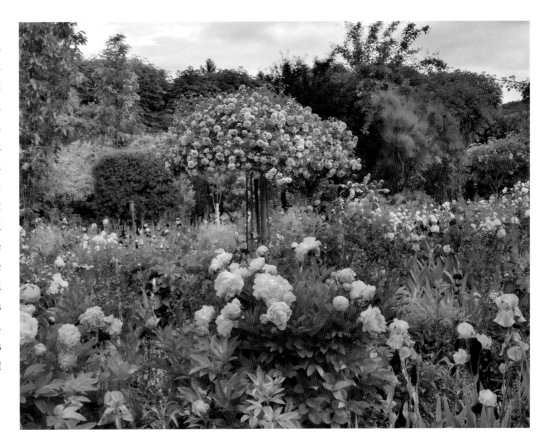

This most delightful icon of Monet's garden is over six feet tall. A climbing rose has been grafted onto a standard rose trunk, which in turn has been grafted onto hardy rose rootstock. This small-scale climber is trained onto a metal *tuteur* in the shape of an umbrella. The medium-sized roses are prolific bloomers, but they are tender, requiring protection from harsh winter freezes and winds. They also demand careful pruning and training, but the work is well worth it, as they bring an elegant beauty to the garden. A standard rose like this would make a stunning focal point in a container for an entryway or a balcony garden. For ideas about how to include such a spectacle in your garden, see pages 92–95.

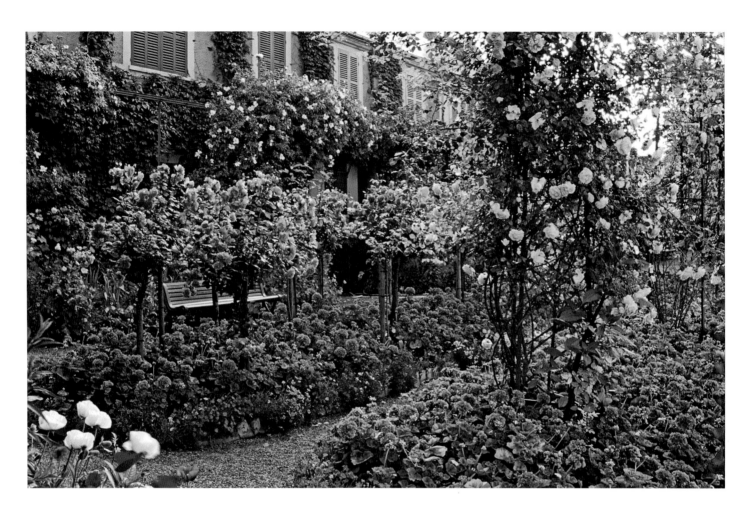

The oval, monochromatic island flower beds in front of Monet's house echo the facade's color scheme of pink and green. In the spring, soft pink tulips are overplanted with pink, rose, and red English daisies (*Bellis perennis*), a perennial often used as an annual flower. In the summer and autumn, the beds are changed to pink geraniums (*Pelargonium × hortorum*) edged with old-fashioned pinks (*Dianthus plumarius*). These perennials, with their spicy fragrance and silver-blue grassy foliage, help stabilize the soil of the raised beds. Standard Queen Elizabeth roses reign above the geraniums at eye level, while white climbing roses grow up a tall *tuteur* and single yellow 'Mermaid' roses bloom below Monet's bedroom window. This rhythmic repetition of color integrates the house with the garden.

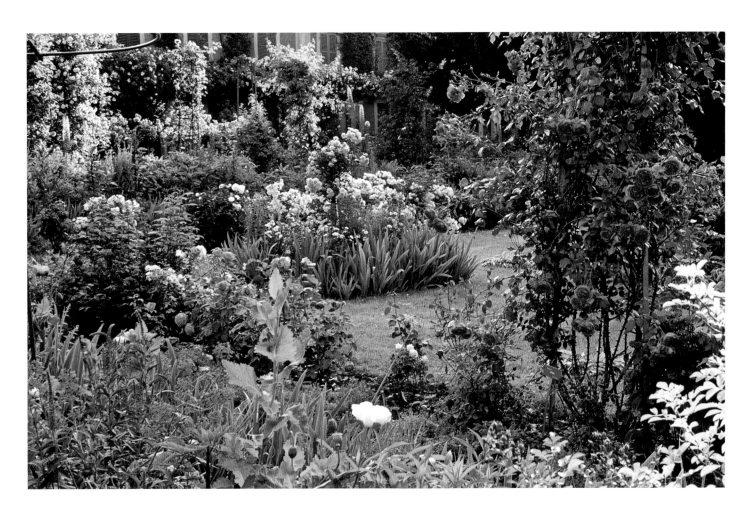

More flowering carpet than lawn, grassy areas are backdrops for more flowers. Monet used thousands of Dutch bulbs, the harbingers of spring, to provide early color in every shade he desired. Some bulbs, particularly narcissus, have been naturalized in the lawn; others, such as tulips, are replanted each autumn. After cutting and pulling back the sod like a carpet, the gardeners plant bulbs with bone meal and then replace the sod. After the bulbs finish blooming, the lawn is mowed around the bulb foliage until it yellows. Irises and poppies are planted in squares cut out of the lawn around standard roses and romantic climbing roses, which are grown on the iron *tuteurs*.

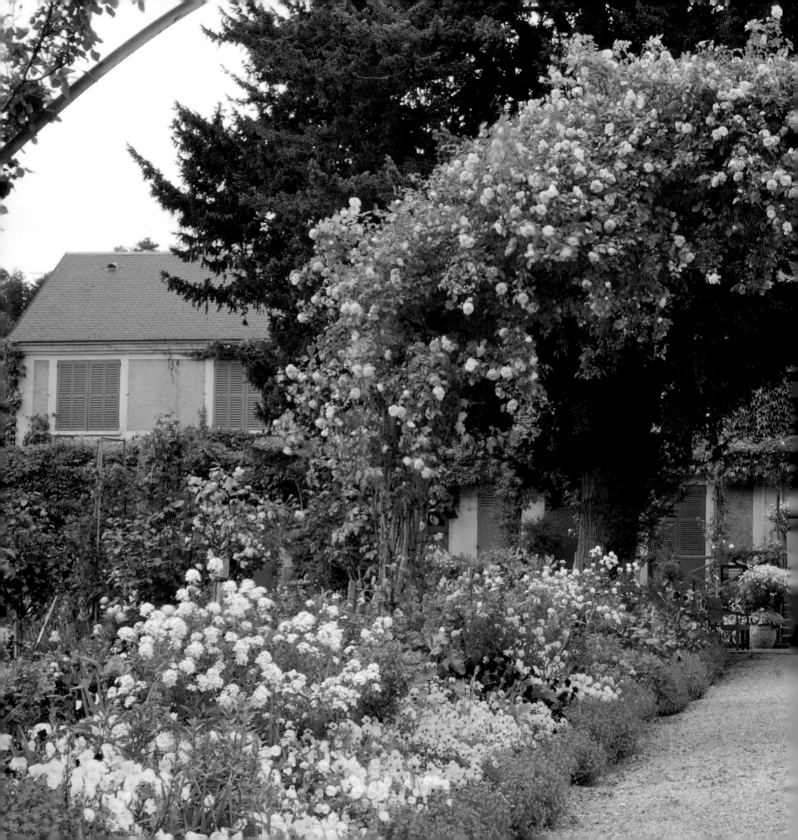

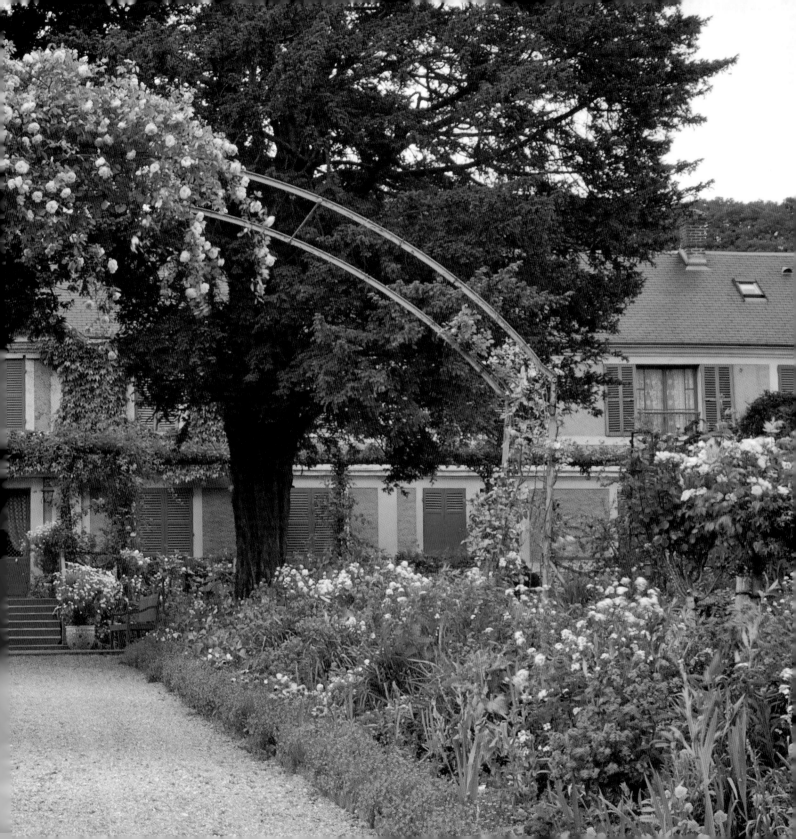

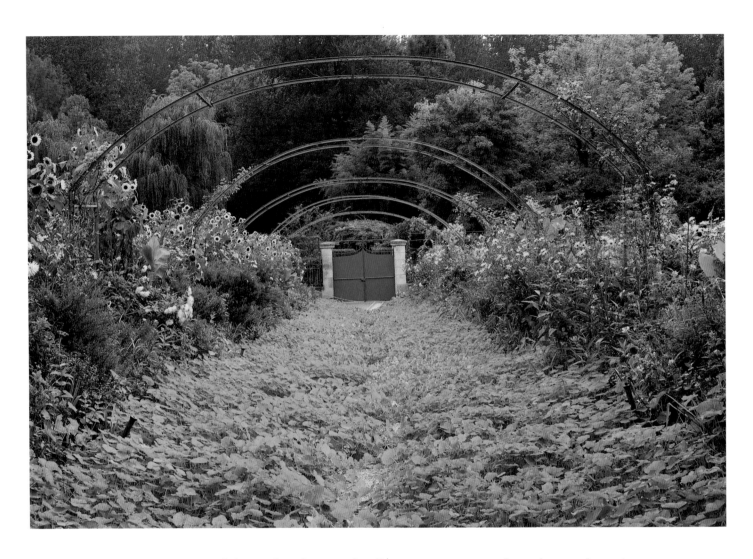

The central axis or spine of the garden, the Grande Allée connects Monet's front door to the main entrance gate. Beyond the gate lies the water garden. This flowering tunnel is of great proportions, with 13-foot-high iron arches placed 22 feet apart along a 10-foot-wide path planted on both sides with rambling roses in 7-foot-wide raised flower borders. In the springtime, before the nasturtiums had spilled into the path, Monet loved to invite guests to lunch and walk them down this path and across the way to the water garden.

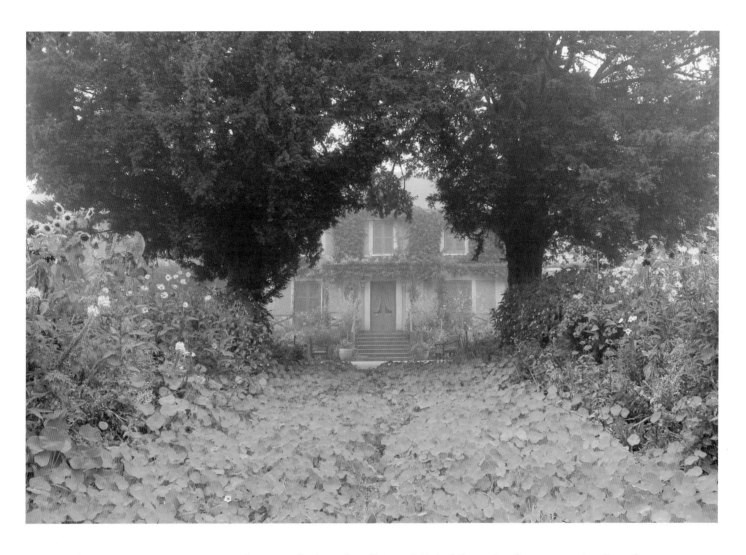

The creeping nasturtiums reach across the broad walk in a delightful tangle of orange and yellow flowers and bright green saucerlike leaves, completing the tunnel effect. Monet planted the tallest plants— sunflowers, dahlias, and asters—in raised beds at the back of the borders. In the late afternoon autumn light, as the vaporous mist envelops the Grande Allée, the backlit nasturtiums resemble illuminated stained glass.

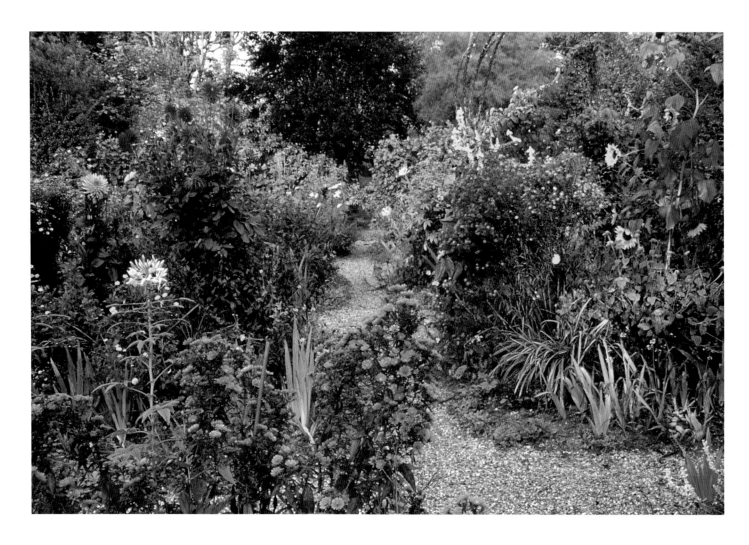

In the autumn, Monet's garden is transformed into a riotous dance of celebration. Gold and shades of lavender and purple dominate the rampantly growing plants. Huge bouquets of Michaelmas daisies and mauve, purple, pink, and white asters grow 4 to 6 feet tall, and towering dahlias in apricot, yellow, and crimson are at their full glory.

Sweeps of golden sunflowers (*Helianthus multiflorus*) bring the sunshine down to earth and dazzle all the flower beds. Hot pink cosmos add their cheerful and carefree dance to the packed borders. The autumn is a time of great abundance. The garden offers all its remaining flowers, the weather cools, and apples ripen. Yellow confetti leaves and flower petals are scattered across the paths in a glorious last hurrah before the onset of frost and winter dormancy.

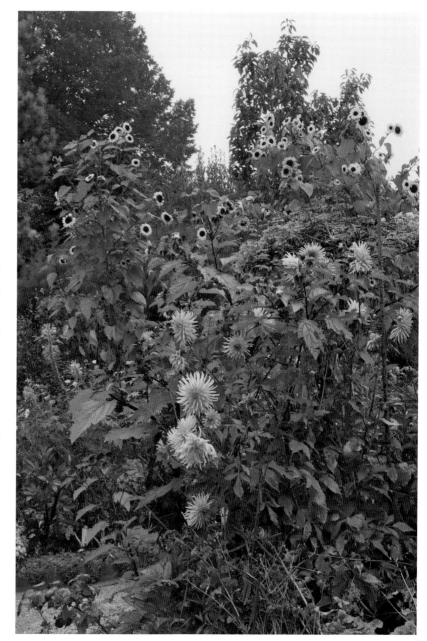

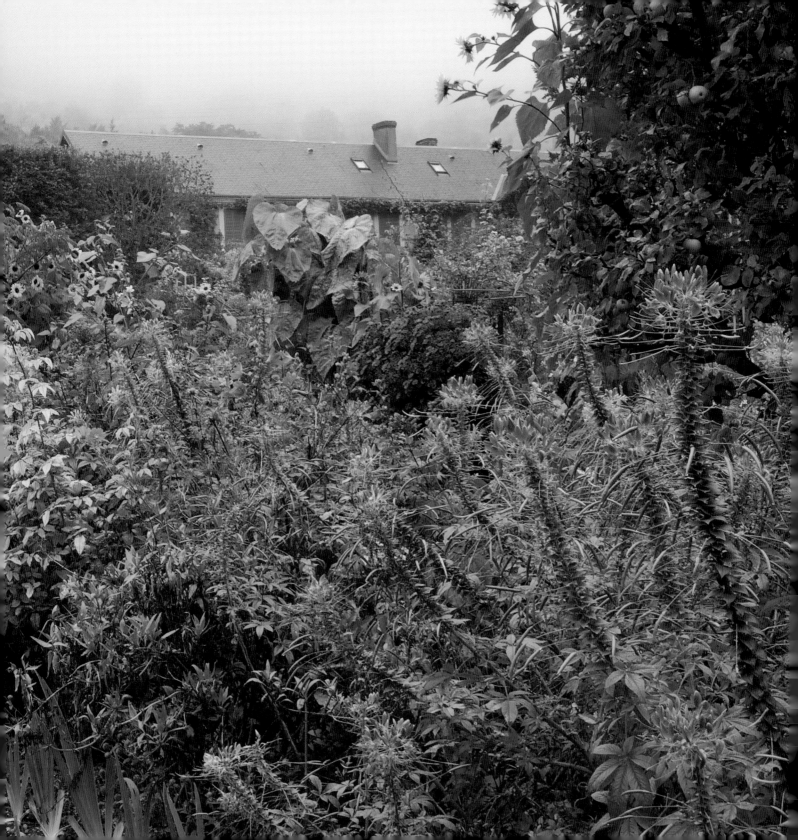

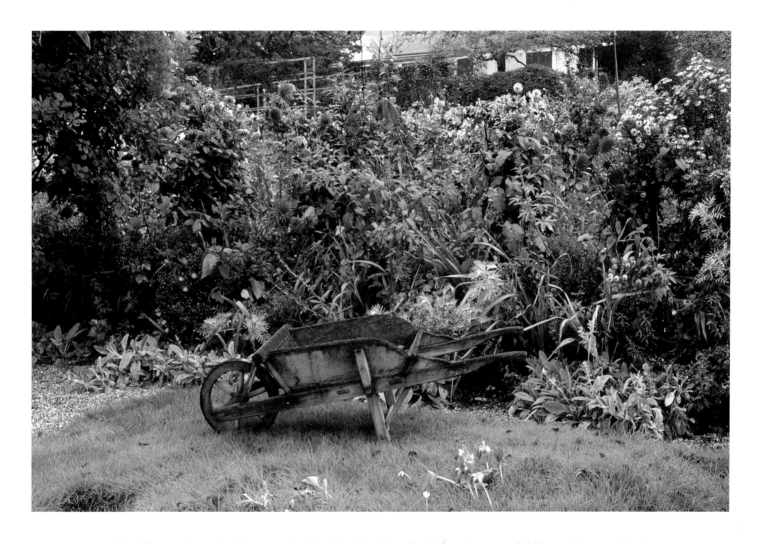

The old wooden wheelbarrow sits beside a border of pink and mauve dahlias and asters that is edged with velvety silver lamb's ears (*Stachys byzantina*) on a lawn sprinkled with fuchsia pink autumn crocus (*Colchicum*).

By autumn a profusion of blooms takes over and the "orderly disorder" gives the garden a spontaneous feeling of wild abandon. To successfully achieve this look, a strong underlying structure to the garden works best.

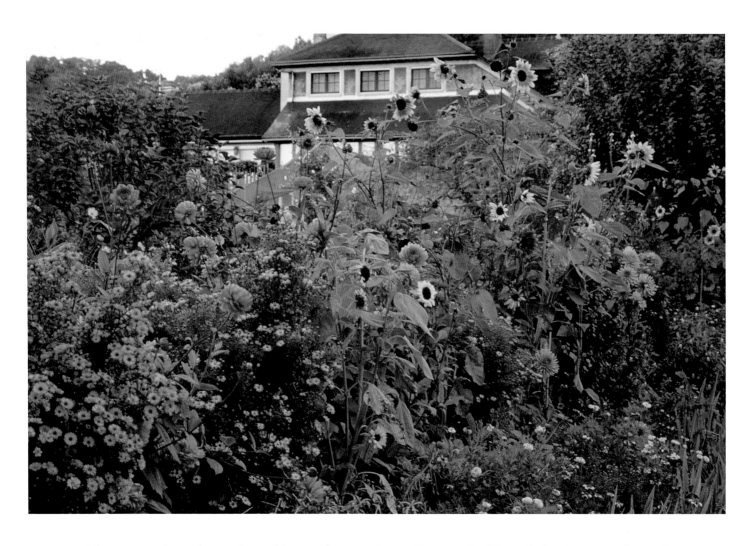

The warm colors of towering golden sunflowers, deep yellow marigolds, and glowing tangerine and persimmon dahlias blend harmoniously with the cool lavender starlike asters. Monet's second studio is seen beyond the flowers. Formerly an old barn, the renovated building housed a work space, an apartment for the painter's grown stepdaughters, a guest room, a garage, and a darkroom where Monet developed photographs. A third studio, far grander, was built in 1915 for painting the enormous water lily murals.

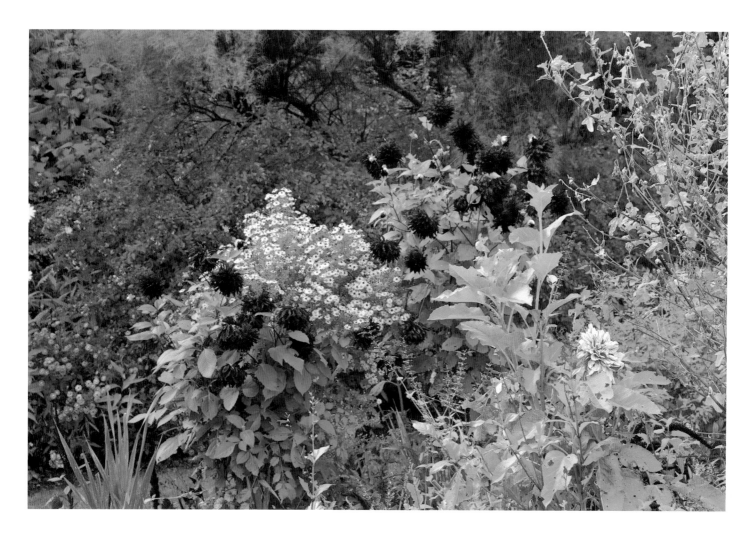

Deep crimson dahlias are embroidered with the light smoky blues of loose drifts of asters. A bright orange
salvia interjects dashes of hot flame. Monet loved dahlias and collected many unusual ones;
the pale cotton-candy pink dahlia with hot lipstick stripes is an uncommon specimen.
In the early years of the garden, he would occasionally trade with Gustave
Caillebotte, an avid gardener, fellow painter, and patron, offering
some of his prized tubers for special orchids or ferns.

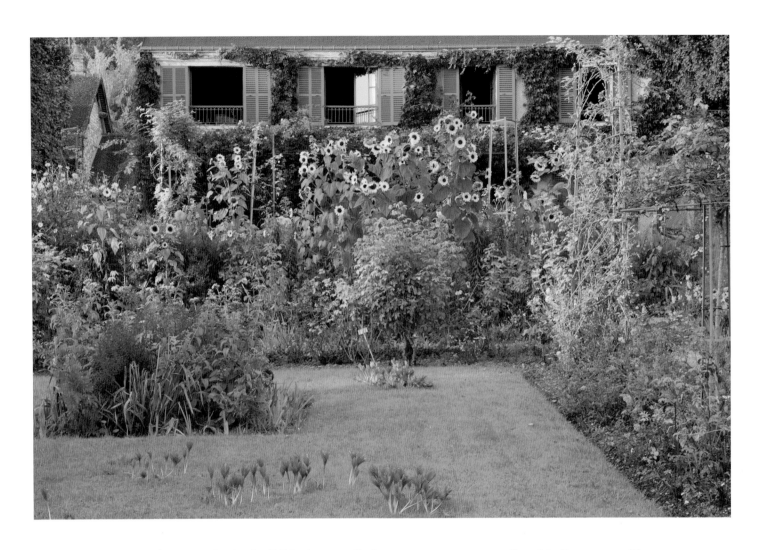

A complete surprise in the fall is the so-called autumn crocus—actually a Mediterranean lily.
Here the fuchsia pink and lavender flowers dot the lawn in front of Monet's house.

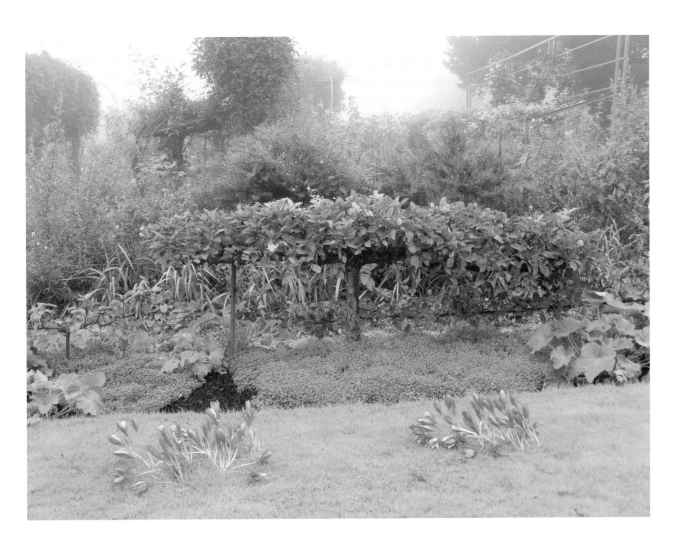

Surrounding one of Monet's lawn areas is a series of espaliered dwarf apple trees used in place of a split-rail fence. Their branches are trained to grow along horizontal wires supported by posts. Normandy is known for its apples, and an "apple fence" is an excellent way to create a light, open boundary in a garden. If espaliered along a warm, protected wall, apples may come earlier, and the trees can do well in marginal climate areas, where a tree out in the open might not succeed. Espaliered trees require careful pruning but fruit production is very high for a small space. To learn more about espaliered apple trees, see page 93.

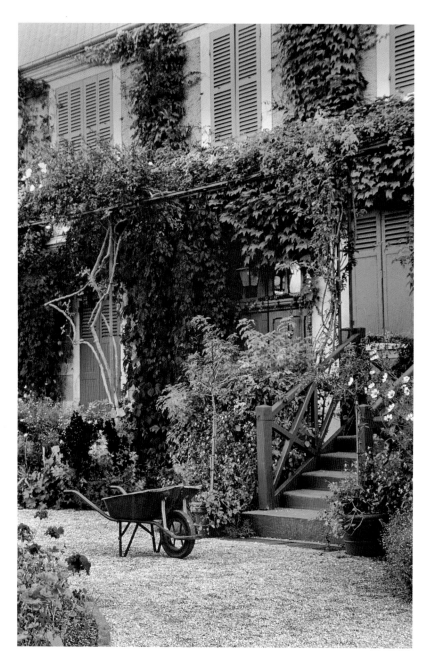

Monet's house turns from pink to deep burgundy in the autumn, when the Boston ivy (*Parthenocissus tricuspidata*) vines attached to the stucco exterior begin to turn color before going dormant for the winter. A few lingering blossoms of the single yellow 'Mermaid' rose grace the green iron trellis across the front of the house.

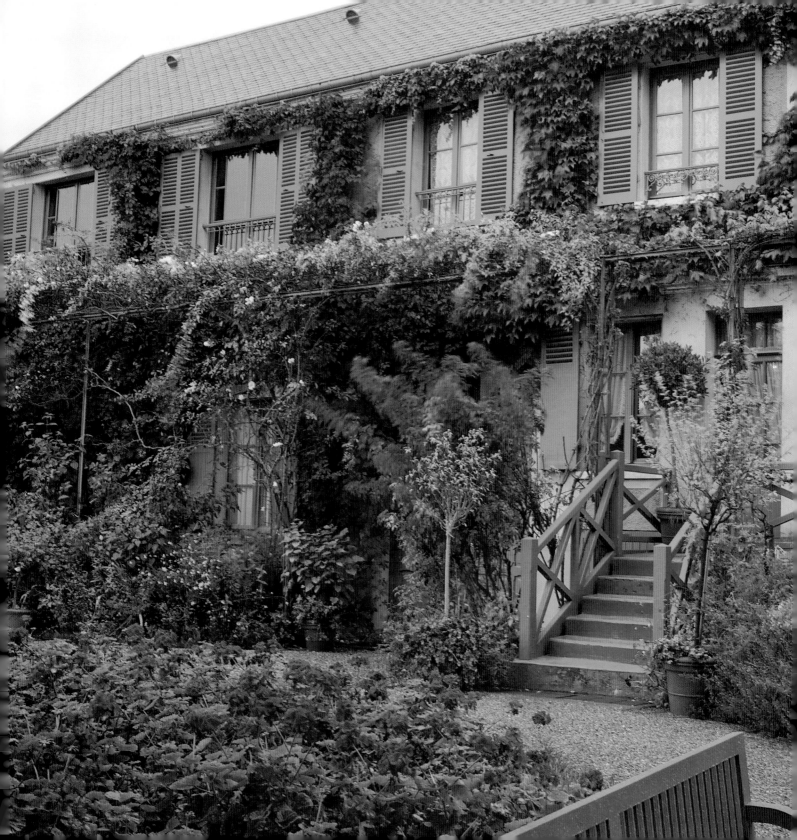

Dramatic violet purple bouquets of asters add stunning concentrated color among the golden sunflowers, rudbeckia, yellow mullein spires, and lacy white nicotiana and cleome (*C. hassleriana*). Autumn's prolific abundance of plants is much taller—6 to 8 feet—than summer's; it's the final great push before early freezes knock everything down.

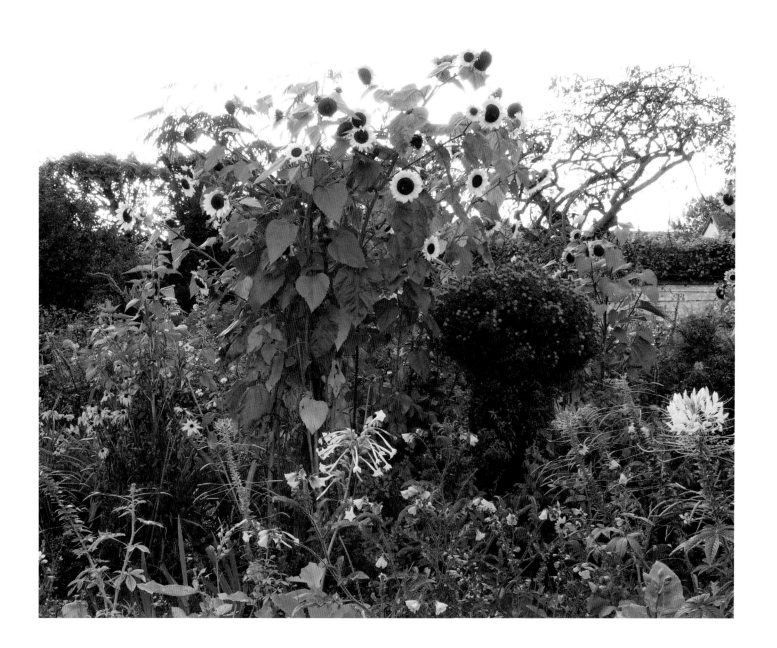

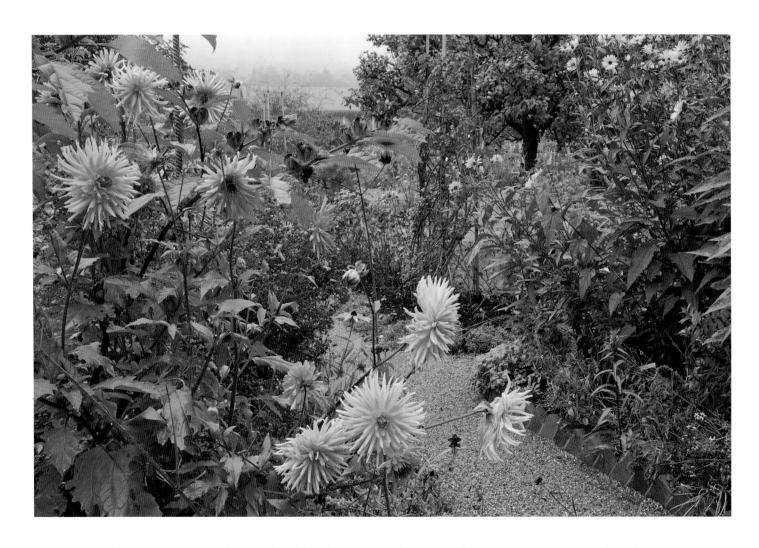

These pink cactus dahlias, with their distinctive reflexed petals, were among Monet's favorites.
Dahlias come in at least 12 different flower sizes and shapes and in all colors except pure blue.
They make prized cutting flowers and are stunning in summer and autumn gardens.

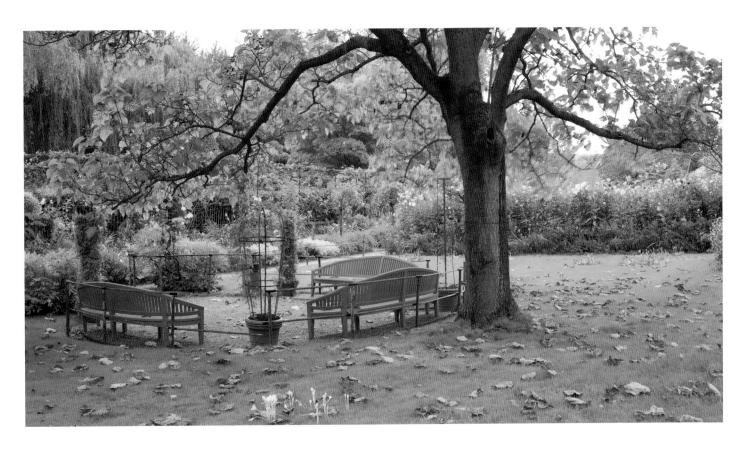

Three curved-back benches are set in a circle under a lovely tree, beckoning visitors to sit, enjoy, observe, and contemplate. Monet spent a great deal of his waking hours closely observing his gardens—looking at the light, evaluating a particular color scheme, or determining whether a vista needed to be opened up to create a better view or more interesting light patterns. If a plant seemed out of place, he did not hesitate to move it to a more advantageous spot. Observation is one of the most important skills for a garden artist to develop, and a carefully positioned bench can be a useful tool. Select one that is comfortable and that complements your garden style. Place it in a quiet, cozy place with a good view of the garden. Monet's favorite bench was under a rose arbor next to the boat dock beside his pond, where he could observe the light and reflections. Benches are also effective as garden features and may serve as a destination at the end of a path.

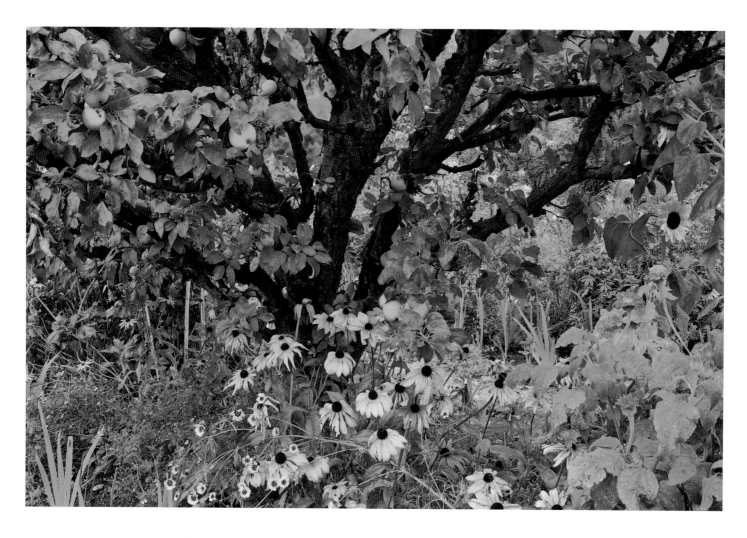

Monet would have liked this planting of golden black-eyed Susans, with pumpkin orange Mexican sunflowers (*Tithonia rotundifolia*), a sprinkling of tiny single orange marigolds, and cheerful yellow cosmos (*C. sulphureus*) with their dark brown centers—all growing under an old apple tree. Originally, Monet's garden had an abundance of such trees for the purpose of making cider. As they aged, he gradually removed many of them to make room for more unusual blooming trees, such as Japanese crab apple and golden chain trees (*Laburnum*), as well as many kinds of fruit trees.

An apple tree—this one full of nearly ripe fruit—adds structure and year-round interest to the garden, as well as providing fresh food. A bright pink annual spider flower, or cleome, lights up the foreground, echoing the pink of Monet's second studio in the background. Sunflowers, black-eyed Susans, and clusters of purple asters are growing in a joyful autumn jumble of rich textures and colors.

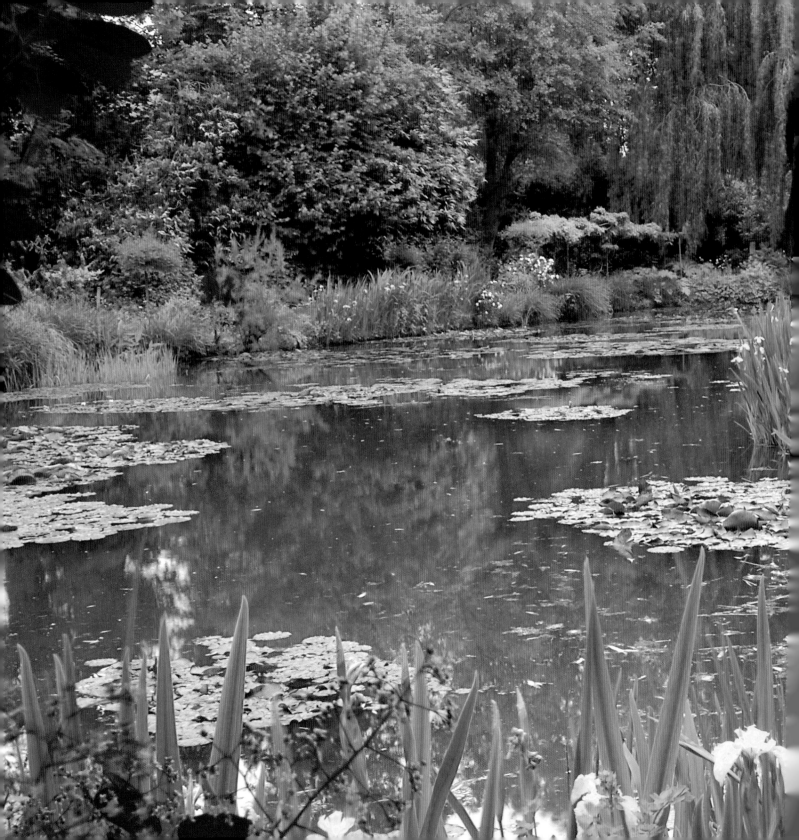

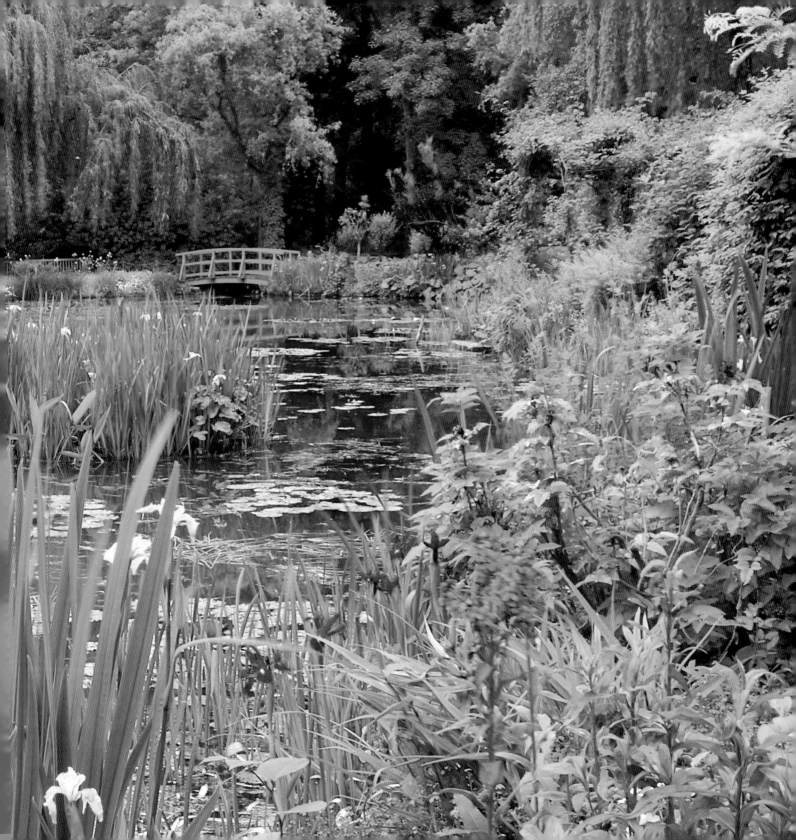

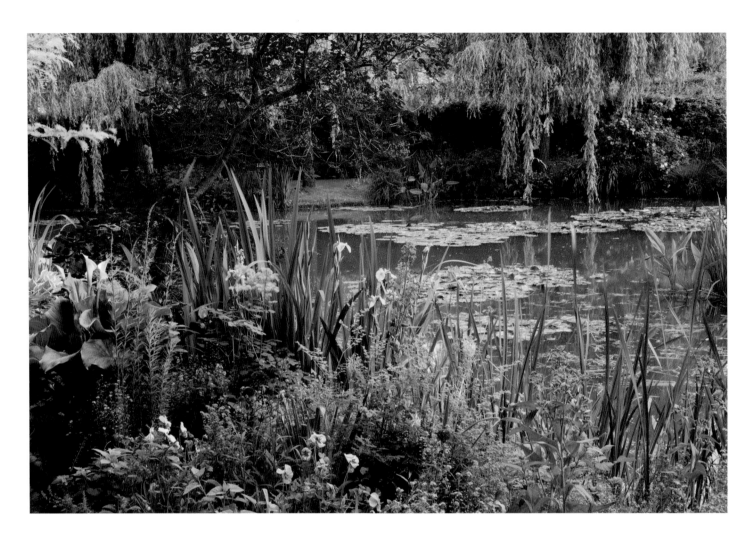

Initiated as a horticultural adventure, Monet's pond became his greatest inspiration and a place of tranquility and renewal. The pond was a mirror that reflected every nuance of atmospheric change—moving clouds and the reflections of trees became abstractions with each ripple of the surface. It held and inverted the landscape as it simultaneously supported thousands of blooming jewels across its surface. This blooming mirror became the motif he would paint again and again for decades, and a focus for deep personal reflection and artistic innovation.

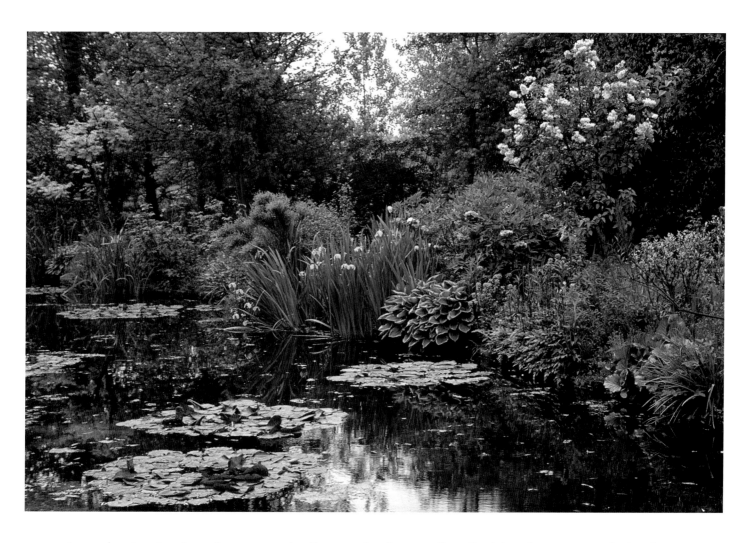

An opulent border along the water's edge features the elegant yellow flag irises (*Iris pseudacorus*), deciduous Japanese peonies in a lovely coral, lemon-edged hostas (members of the lily family grown primarily for their beautiful leaves), deep golden English wallflowers (*Erysimum cheiri*), and a standard white lilac. The border plays an important part in the beauty of the garden in early spring before the water lilies are in bloom.

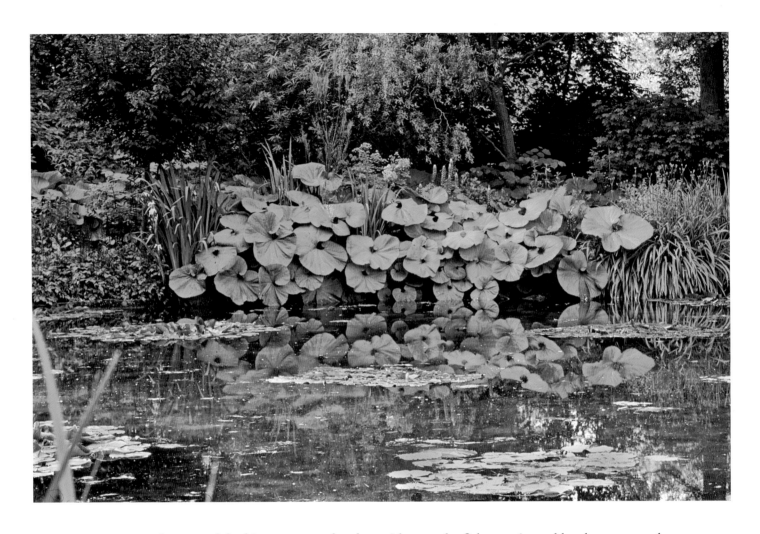

Monet wanted a natural-looking water garden, but with a touch of the exotic, and he chose many plants from the Far East that contributed to this effect. Plants that cascade and overhang the edge, like the round-leaved coltsfoot (*Petasites japonicus*), add stunning form to the reflections. In addition to the different kinds of irises he grew next to the pond, Monet also planted blue lily of the Nile (*Agapanthus*) and orange daylilies, as seen in his paintings.

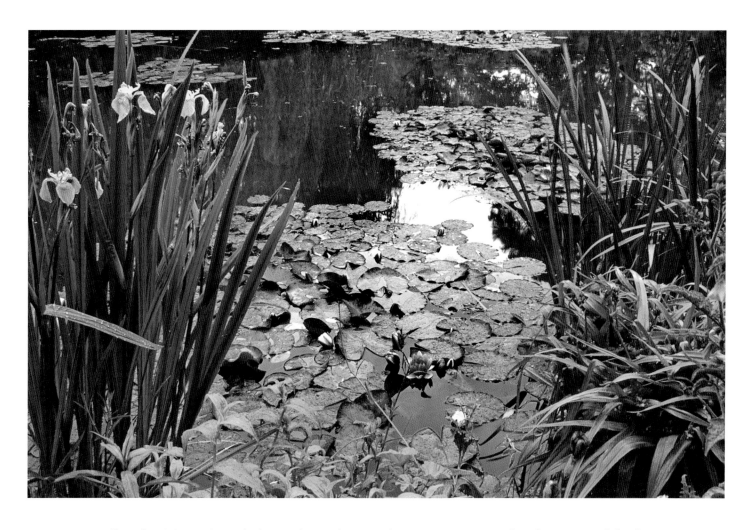

Yellow flag irises pair with the scarlet spiderwort (*Tradescantia virginiana*) to frame one of the first water lilies to bloom. Spiderwort, like yellow flag iris, likes lots of moisture and can take the damp, boggy conditions at the pond's edge. It also comes in white and shades of blue, lavender, pink, and near red.

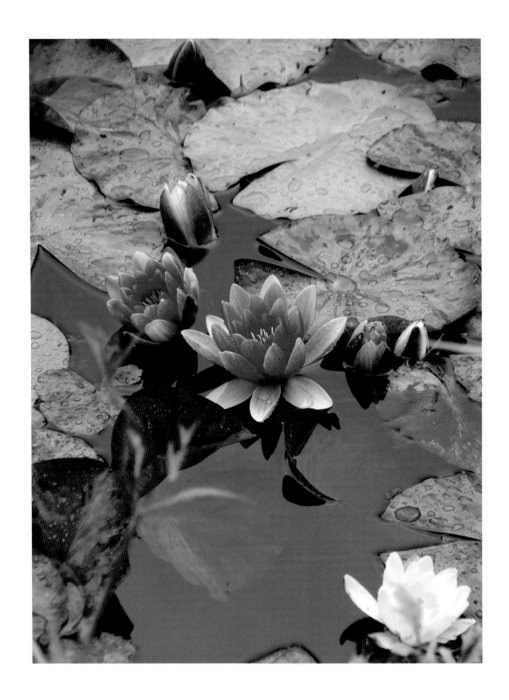

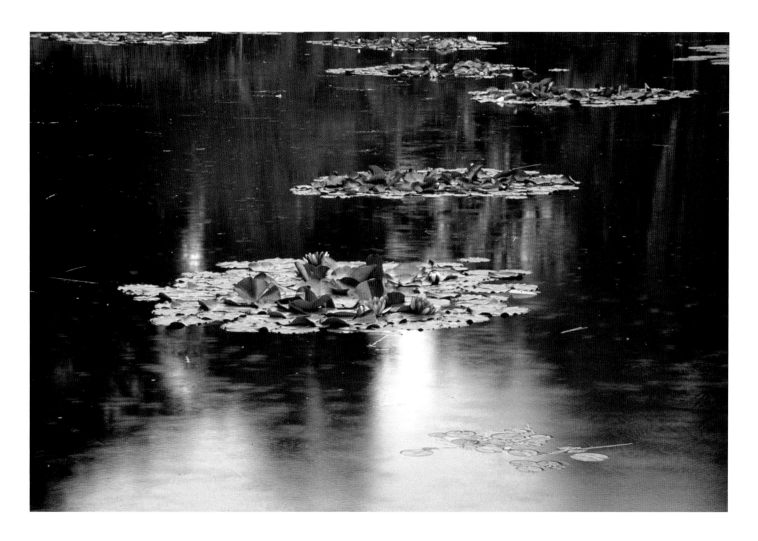

The crowning jewel of Monet's water garden is the collection of water lilies, both hardy and tropical varieties. The tropical lilies—in rare blue and lavender colors—must overwinter in the greenhouse. From late spring to early summer, the water itself seems abloom with Monet's floating flowers. Interrupting reflections of clouds, these imperial flowers open and close with the sun.

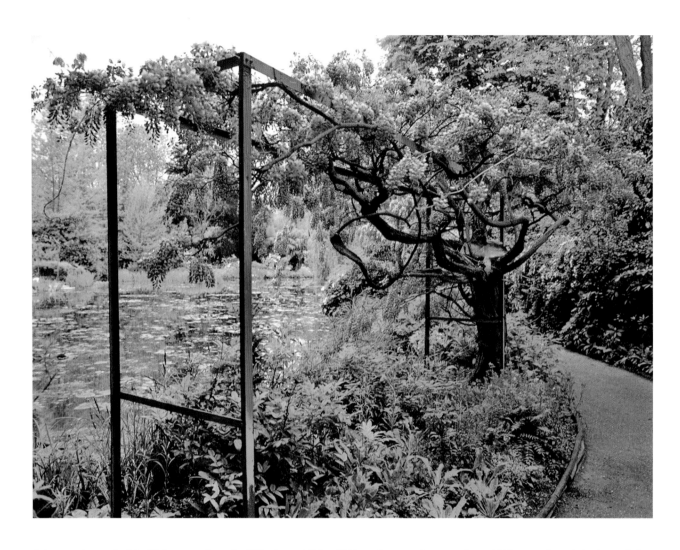

Monet planted this Chinese wisteria (*W. sinensis*) in 1911 at the northeast edge of his pond and designed the 34-foot iron arbor to support its deciduous woody vines. These long-lived legumes bear exceptionally beautiful clusters of delicate florets shaped like small sweet pea flowers. The variety shown here produces 12-inch flower clusters in the spring, before the leaves have appeared. Monet painted large abstract paintings of this wisteria in his last years. The Japanese variety (*W. floribunda*) has longer clusters, up to 18 inches long, but blooms later, after the leaves come out.

Under arched trellises covered with pink
climbing roses, Monet placed a bench
so that he could sit and look out across
his pond to the Japanese footbridge.
In front of the bench, several rounded
concrete steps lead directly into the pond.
A flat-bottomed boat was often tied here
so that the water gardener could clean
the pond surface and feed the water lilies.
Monet and his family loved boats, and
he kept three on the river, two of them
equipped as waterborne painting
studios. The trellises over the
dock provide year-round interest,
as they create an interesting
structure even in winter.

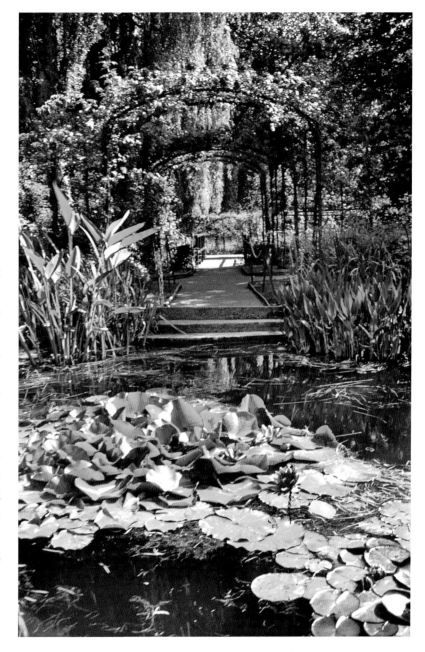

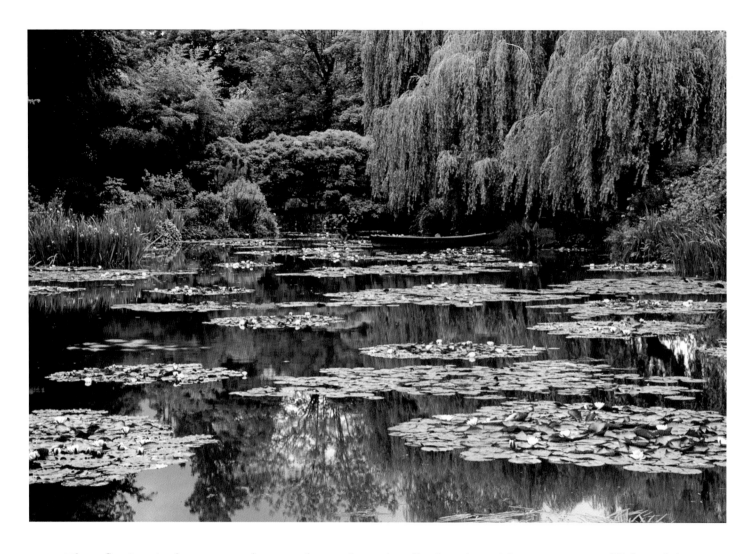

The reflections in the water garden are ephemeral, continually changing with every nuance of light and the passing clouds. Informal groupings of water lilies float across the calm surface.

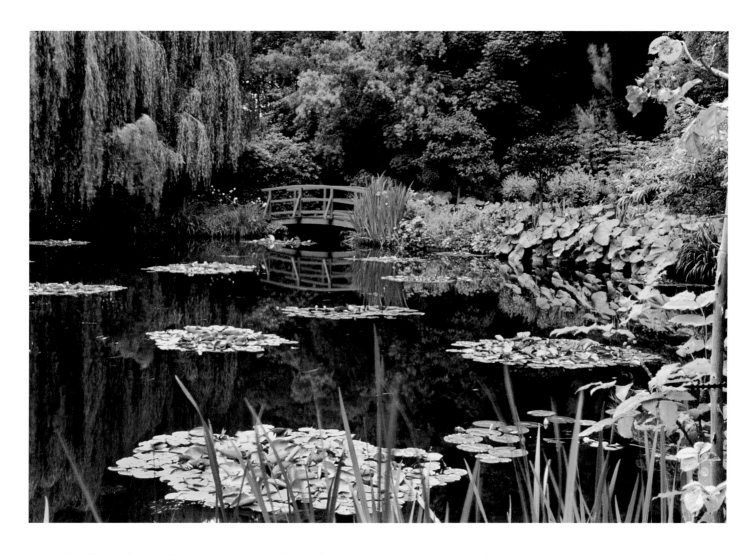

Perfectly clear reflections on the pond's surface were essential to Monet in order to capture them on canvas. Studying this waterscape, Monet faced the ultimate challenge of trying to paint the light, the water, the grasses under the water, and the world turned upside down. His later paintings became very abstract, lacking a horizon line to distinguish between land and sky.

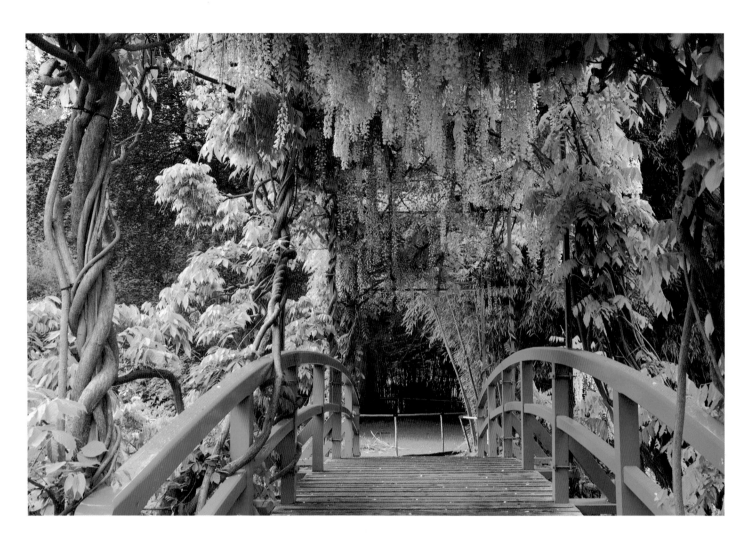

Monet designed this gracefully arched wooden bridge—a prominent feature of the water garden—to span a narrow part of his pond. The 18-foot structure was inspired by one of his Japanese woodblock prints. In 1911, following the devastation of major storms and flooding, he repaired and enlarged his water garden, adding the iron arbor. He trained the white Chinese wisteria along the lower handrails and the long lavender Japanese wisteria along the arbor; when in bloom, they create a canopy of lace. The reflections of the bridge in the pond below are magnificent.

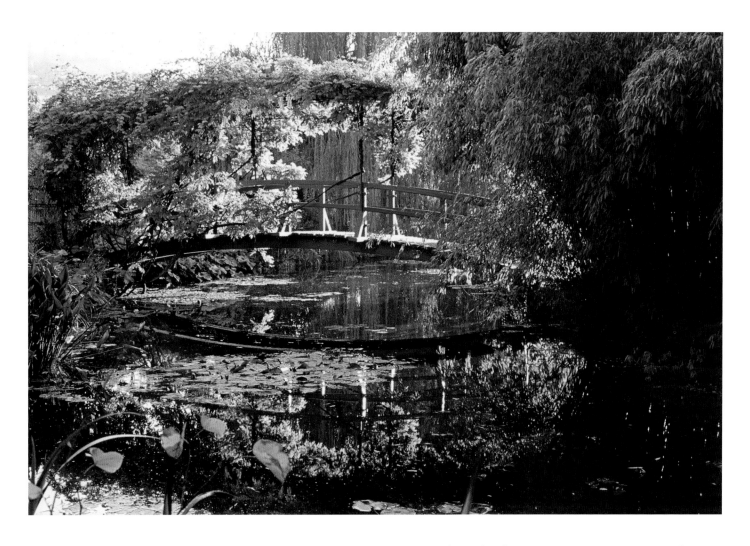

Just as the sun rises, dawn's golden light illuminates Monet's bridge. This fleeting moment casts a magical spell over the pond. Monet worked to capture this shimmer of mist and light—the very atmosphere itself—on his canvases. The velvety string bean–like seedpods of the wisteria hang as harvest offerings over the Japanese footbridge. On the other side of the bridge, Monet's collection of graceful bamboos grows luxuriantly.

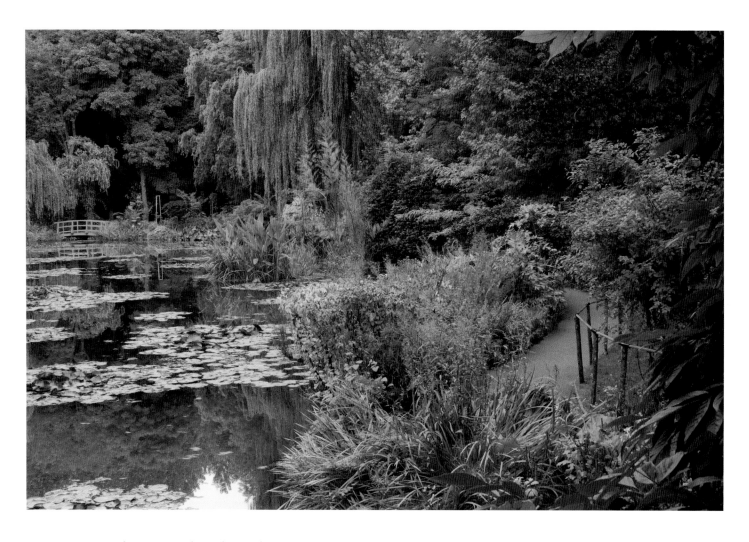

In keeping with traditional Japanese garden design, surprise elements pop up along the path,
such as some special bulbs in bloom; a visitor has a greater sense of discovery when
not all is seen at once. This partial view and the curves around the
pond also lend the pond a feeling of greater scale.

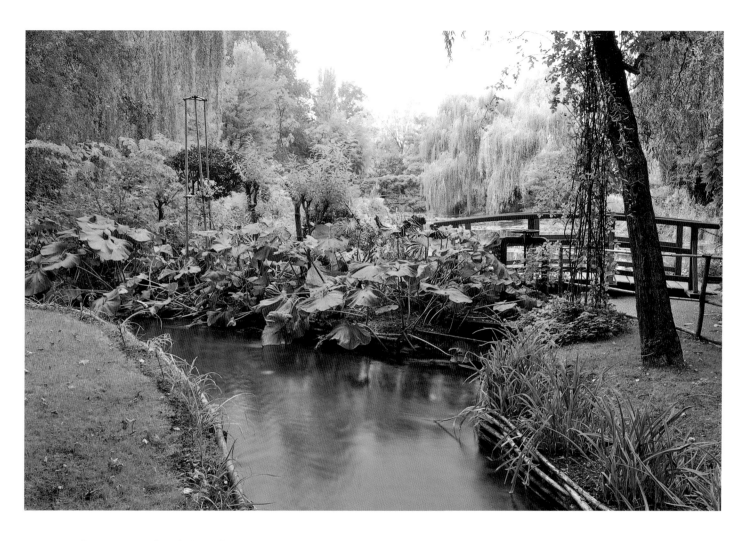

After a storm flooded his first garden, Monet launched an enormous excavation project and rerouted the Ru, a tributary of the Epte River, diverting the water with two weirs. Here, a weir directs fresh water from the Ru into the pond, to wash it out and maintain proper levels. At the other end of the pond, past the large bridge, another weir lets water back out downstream.

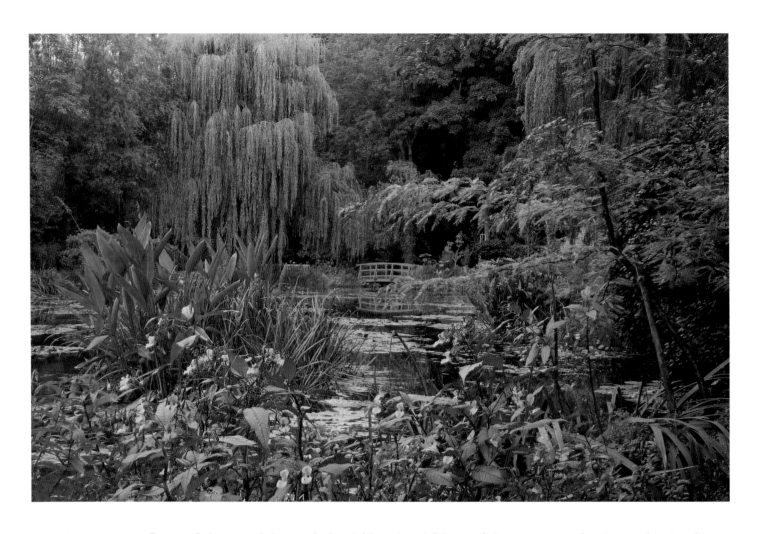

In autumn, as flowers fade around the pond, the richly colored foliage of the many trees dominates the visual splendor, and the colors reflected in the water include gold, orange, and red from the liquidambar, maroon from the copper beech (*Fagus sylvatica* 'Atropunicea'), and yellow-green from the poplars (*Populus nigra*) and the weeping willow trees (*Salix babylonica*). While the small island obscures most of the far bank to the left, pink balsam (*Impatiens balsamina*) in the foreground frames the golden tapestry woven around the small green bridge visible at the far end of the pond. There is enough calm to create a pretty reflection of the green bridge in the glow of the early evening light.

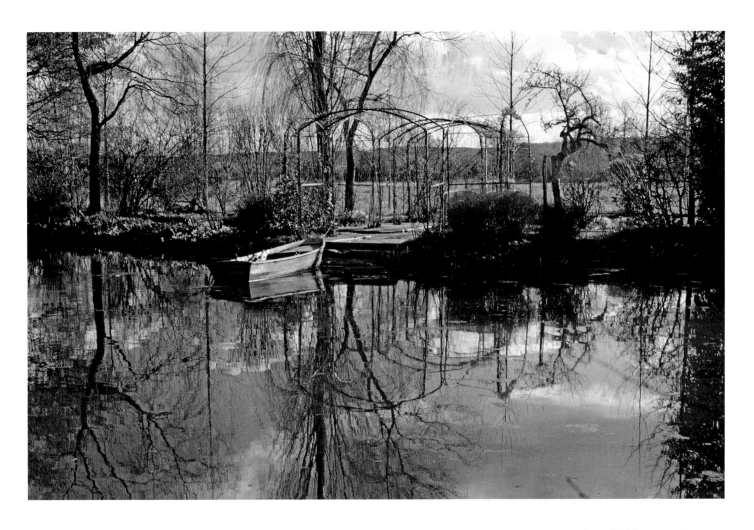

Winter is the best time of year to study a garden's bones, since the structure is not covered with foliage and flowers. Even so, many gardens look sparse and uninteresting during their time of dormancy. Here, the reflective water, the strong architectural elements of the boat and the arbors over the dock, and the surrounding trees make this part of Monet's garden quite charming. The meadows beyond the pond, which have never been developed and are used to graze sheep, provide a borrowed landscape that extends the view.

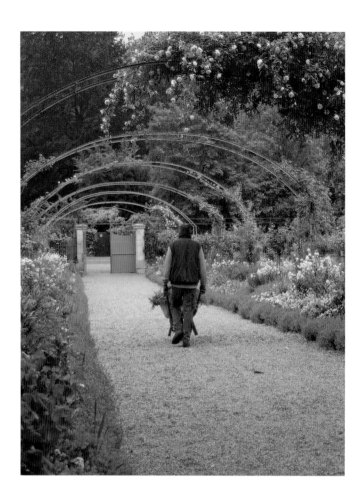

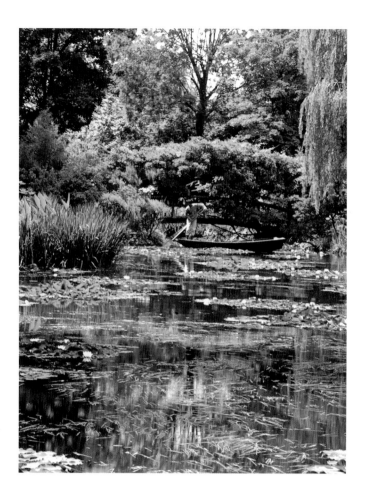

Surrounded by the full spring bloom
display of the Grande Allée, a gardener
heads for the compost pile with
a wheelbarrow full of
garden trimmings.

Just like in Monet's day, when he assigned one
gardener to maintain the water garden and
clean his pond for perfect reflections, today's
gardeners use the same type of flat-bottomed
boat. Balanced like gondoliers, they skim
algae, grasses, and spent water lilies from
the water's surface. All the green matter
is added to the compost pile and will
later enrich the gardens.

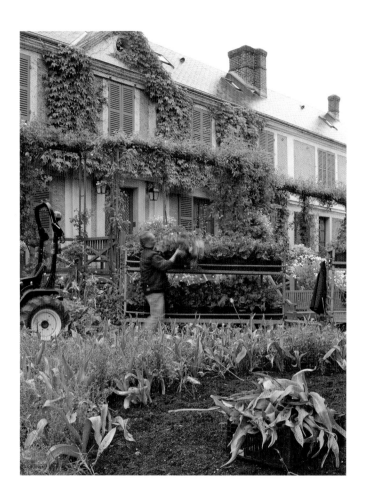

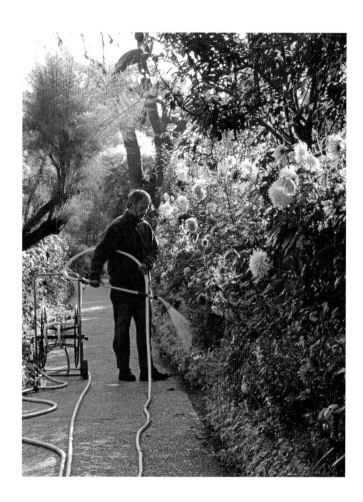

The hardworking gardeners dig up the spent pink tulips and blue forget-me-nots after their spring glory. Red and pink geraniums (*Pelargonium × hortorum*) started in the greenhouses are ready to be planted for an instant show of color in front of Monet's house.

Yves Hergoualc'h has worked in Monet's garden for three decades, second in command under Gilbert Vahé. In late September, Yves waters the dahlia border first thing in the morning, since there has been no rain for several weeks.

Chapter Three
BRINGING GIVERNY HOME

———•◦•———

More than anything, I must have flowers, always, always.

—CLAUDE MONET

Monet's gardens teach us that in gardening we have an opportunity to work with natural elements in an artistic, organized manner, both to create art and to cultivate an intimate relationship with and respect for our land and the natural world, especially if we garden organically and in rhythm with our local ecosystem. Our gardens can sustain, inspire, and nurture us and our communities. They are places that bring us inner peace and ignite our passions. In cultivating a garden one cultivates oneself.

For Monet, gardening was about creating beauty and deepening his connection to nature. He experimented with color combinations, visual effects, reflections, time of day, and even the transparency of petals to achieve varied outcomes. He routinely moved plants to achieve a desired effect.

In your garden, consider trying some of these: succession plantings that weave bulbs and annuals into perennial borders to provide color for all seasons; large blocks of monochromatic colors for impact, or complementary colors next to each other for increased intensity; using scale and borrowed landscape to increase the sense of size of the garden; specific colors to increase atmospheric effects of mist or sunlight; bringing color up into the sky with the use of trellises for roses and flowering vines; capturing reflections of the sky and landscape with a water element.

A good way to observe color combinations is to consider a small bouquet of flowers and foliage in the light. Some colors create harmonies, while others clash. Also note shapes of flowers—are they round like a rose, tall and narrow like a delphinium or foxglove, or sculptural like an iris? Keep in mind heights, blooming times, leaf shape, color, and cultural requirements as you create your planting compositions.

Just as Monet would collect wildflower seed and plants on his walks and travels to plant in his garden, you can invite the wild into your cultivated space by using as many native plants as possible; drifts of native plants can create much-needed habitat for birds, butterflies, and other pollinators. Saving seed and dividing plants can help you increase the number of plants to add to your garden and to share with others. The humble work of improving your soil with compost will greatly benefit the garden. Establishing your water needs is also essential. Depending on your location and rainfall, you may want to catch rainwater from your roof and store it in tanks or use gray water from household washing to irrigate the garden, thus lessening your impact on your local water supply.

CULTIVATE HOPES & DREAMS FOR YOUR GARDEN:

- to keep your vision clear, make a collage with pictures of gardens and plants you love
- decide on the location of the garden; study its light patterns and soil type
- assess your features and challenges (a great tree, or a view to block)
- determine desired bloom times
- make paint swatches of colors you like that complement your environment or home interiors; if you have a dominant feature like a blooming tree, great fall color, or an architectural element, keep its color in mind when you select plants
- calculate time and cost of installations and maintenance, including irrigation (are you doing it alone over time or will you be able to hire professional help?)

SELECT YOUR PLANTS:

- familiarize yourself with the best uses of bulbs, annuals, perennials, vines, shrubs, grasses, and trees
- visit local gardens and nurseries
- learn which plants are native to your area, including wildflowers
- note the special characteristics of the plants you are considering, such as shape, texture, and size at maturity
- pay attention to the cultural requirements of the plants you are considering, including climate, sun, water, soil type, and fertilizer
- consider whether you have deer or gophers in your garden; select plants they don't like or establish boundaries with a deer fence or gopher baskets

After you have made decisions based on the above criteria, draw up a list of the plants in your chosen colors, keeping in mind their bloom times. The more you've thought about it, the shorter your list will be.

The garden designs on the following pages use Monet's color theories and planning ideas. "The Blooming House" shows how to incorporate your home as a charming garden feature. "Balcony Gardening" features container plants and elements that are signatures in Monet's garden. These can be used in the ground as well as in containers. The "Paint Box" designs can be adapted to different sizes and places; one design is a potager, or kitchen garden, and the other shows seasonal color combinations that appealed to Monet. Finally, the "Blooming Mirror" draws upon Monet's own lily pond to demonstrate an easy and inexpensive way to experiment with the joys of water gardening.

These designs can be followed precisely, or they can serve as starting points for your own painterly garden. The line drawings on the overlays show the layout of all the annuals, bulbs, and perennials, while the color drawings show what the garden will look like in bloom. Keys identify the plants used in each design. You can use these diagrams as models for your own drawings. After you draw your plan (to scale is helpful), use a tracing paper overlay and fill in areas for spring bulbs with colored pencils. A second sheet of tracing paper can be used to color in an overplanting of annuals. This method will aid you in determining which colors combine well in different seasons and how many plants you will need within the space limitations of your design. Please refer to the chapter on plant cultivation for specific instructions for the planting and care of each plant used.

The Blooming House

A place that says, "Welcome!"

Design elements from Monet's home can be used to make your house "bloom" and be part of your garden. These plans suggest a few architectural features and plants to make your home even more inviting.

- a front door that welcomes with color and decorative lighting
- a path that clearly leads to a welcoming door
- friendly architecture
- potted blooming plants at the front door
- rooms that face the garden, with views from windows or French doors; colors in rooms complement those in the garden
- doors with glass that open to a porch and allow light into the house
- a porch for sitting or dining situated in the garden but close to the house
- plants that cover: vines attached to stucco walls to transform and soften them
- rose trellises that run across the front of the house
- flower beds around the porch foundation
- thoughtful use of color
- benches on the porch and in the garden
- island flower beds near the house that create seasonal color zones
- a framed view: Monet used the arches over the Grande Allée; a smaller home could use an arbor over a gate or a pair of blooming trees

INSTRUCTIONS:

Photograph the front of your house and make a large print. With tracing paper placed over the photo (doing this on a window or a light table will help), draw in details that might work: perhaps a trellis, new front door, shutters, potted plants, a straight or curved path and gate with arbor, flower beds. Assess what works best with your home and personal style. This could also be done with a digital image of your house; use Photoshop to cut and paste in elements you like from other gardens: vines, a window box full of flowers, a blooming tree, a brick path. You can also try out different colors for your house, door, or shutters. Adding decorative pots like Monet's blue and white jardinières will provide year-round color where weather permits. Many times just a few carefully selected details can transform the ordinary into your own personal expression. See "Balcony Gardening" designs for more ideas.

Remember: vines that attach, like Boston ivy, are fine for masonry homes but not for wooden ones. For an arbor choose a strong material, such as a light-gauge metal. Install it where it will add to the beauty of the home and the rooms inside—like a good frame—but will not block views or overshadow the house. Correct proportion is essential; get help from a designer if you need it.

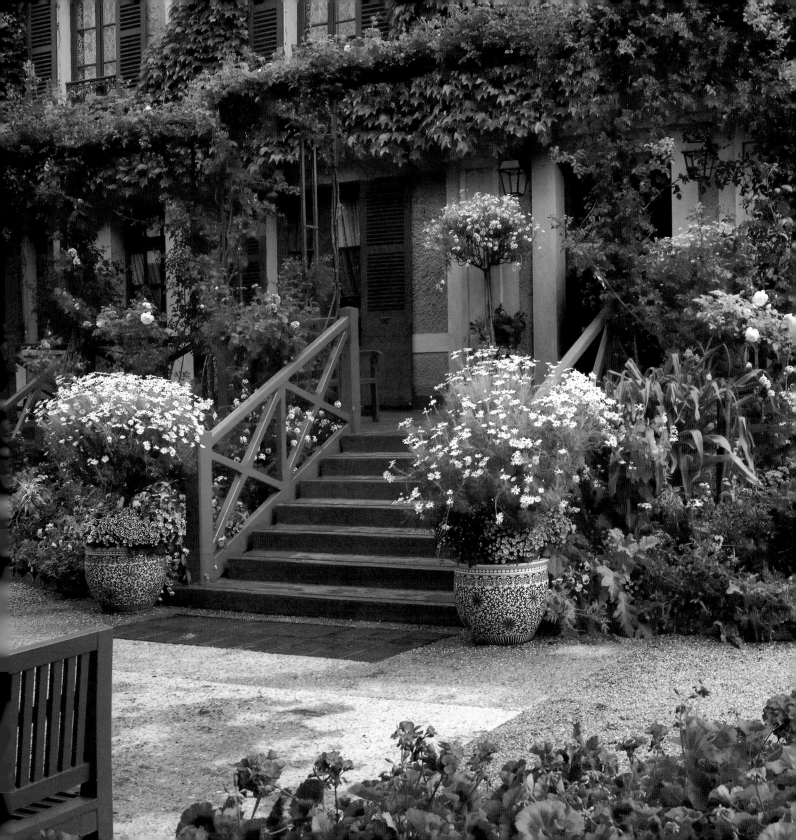

The Blooming House
Architectural Elements

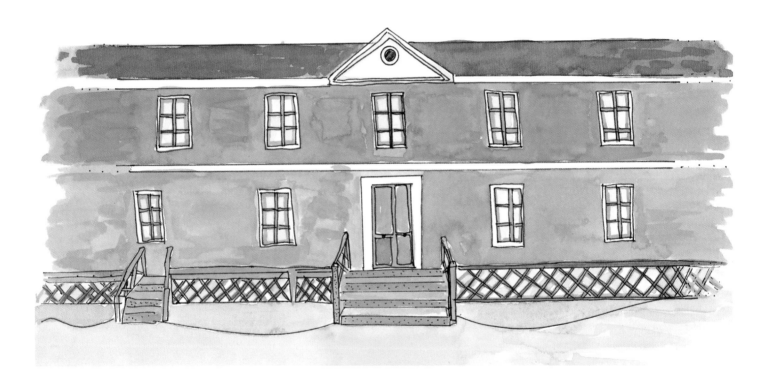

1 SHUTTERS
2 FRENCH DOORS PROVIDE ENTRY TO BALCONY
3 ROSE ARBOR OVER FRONT DOORWAY
4 WINDOW IN DOOR
5 LANTERNS
6 POTTED PLANTS IN BLUE AND WHITE JARDINIÈRES
AT ENTRY
7 BENCHES
8 ISLAND BEDS

1 SHUTTERS

2 FRENCH DOORS PROVIDE ENTRY TO BALCONY

3 ROSE ARBOR OVER FRONT DOORWAY

4 WINDOW IN DOOR

5 LANTERNS

6 POTTED PLANTS IN BLUE AND WHITE JARDINIÈRES AT ENTRY

7 BENCHES

8 ISLAND BEDS

A STANDARD "PARIS" DAISIES IN BLUE AND WHITE
 JARDINIÈRES WITH IVY GERANIUMS
B STANDARD ROSES
C CLIMBING ROSES ON TRELLIS ACROSS FRONT OF HOUSE
D BOSTON IVY ON STUCCO WALLS

E MIXED BORDER WITH BULBS, ANNUALS, AND ROSES
F SURROUNDING TREES
G ISLAND BEDS OF BLUE FORGET-ME-NOTS AND PINK
 TULIPS; CHANGED TO PINK AND RED GERANIUMS IN
 THE SUMMER

A STANDARD "PARIS" DAISIES IN BLUE AND WHITE JARDINIÈRES WITH IVY GERANIUMS
B STANDARD ROSES
C CLIMBING ROSES ON TRELLIS ACROSS FRONT OF HOUSE
D BOSTON IVY ON STUCCO WALLS

E MIXED BORDER WITH BULBS, ANNUALS, AND ROSES
F SURROUNDING TREES
G ISLAND BEDS OF BLUE FORGET-ME-NOTS AND PINK TULIPS; CHANGED TO PINK AND RED GERANIUMS IN THE SUMMER

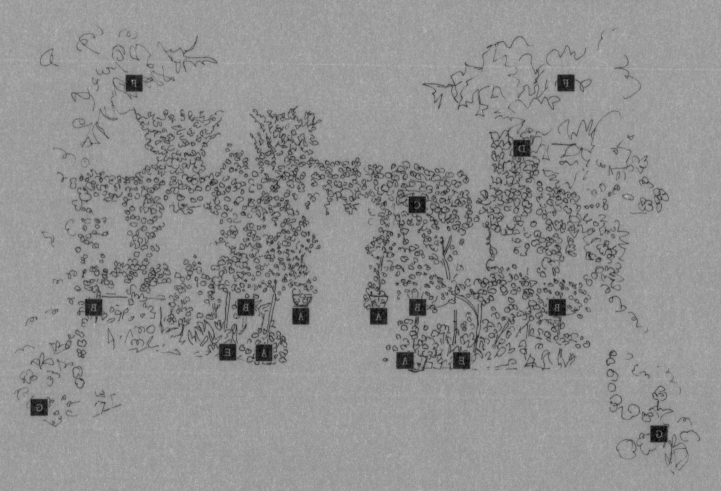

The Blooming House
Plantings

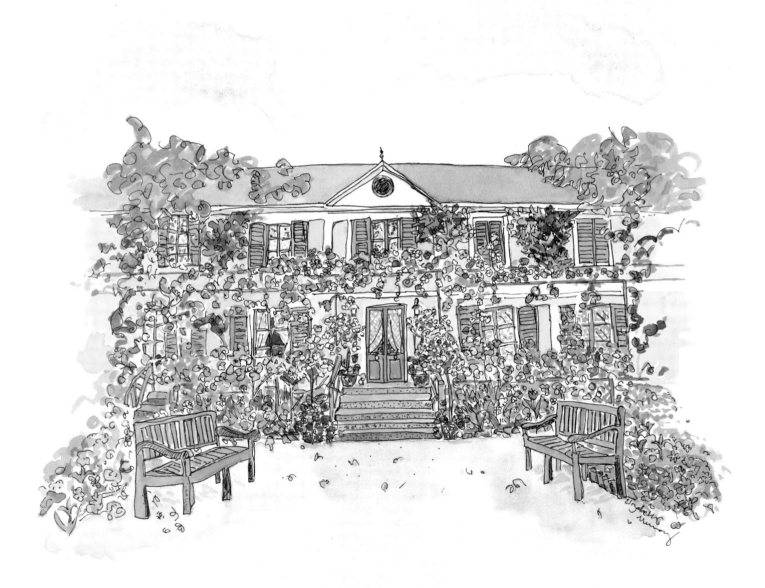

Balcony Gardening with Monet's Signature Plants

Container plants and design elements that sing Monet!

Container plants can create an instant focal point, growing where there is no room for a garden, to magically transform a tiny apartment balcony or gravel courtyard or to add charm to the front entrance of a home. These movable gardens can be changed seasonally for color, using spring-flowering bulbs like tulips or daffodils; summer geraniums, agapanthus, daylilies, or foxgloves; and autumn dahlias, nasturtiums, asters, or even sunflowers. For easy seasonal change, plants can be grown in plastic pots and simply set—pot and all—into decorative containers.

Small trees can also be grown in containers, including espaliered fruit trees, Japanese maples, and some of the smaller clumping bamboos. Vines can be grown in pots if a trellis or obelisk is provided. A small-flowered clematis or even a carefully pruned wisteria standard can be charming in containers. In Monet's garden today, blue and white jardinières at the entrances hold an elegant pair of standard Paris daisies, each underplanted with pink and white ivy geraniums.

Roses, too, are wonderful in containers—standards are quite elegant, and, of course, Monet's pink climbing roses trained on an umbrella-shaped *tuteur* are distinctly reminiscent of his garden. Miniature roses can add much charm to small spaces as well.

Herbs can also be grown successfully in pots, as can salad gardens featuring a selection of lettuces. Even a small water garden can be installed in a large waterproof pot, with miniature water lilies, tiny fish, and, with the addition of a recirculation pump, a little fountain. With a petite water garden, a pot of bamboo, and a blue agapanthus, you would have the basic elements of Monet's water garden.

Create a corner of Monet's flower garden with a standard pink rose, a pot of pink tulips in spring, and pink and red geraniums in summer. If room permits, much could be added, including apple or pear trees, pots of annuals in carefully chosen colors, a pot of wildflowers, and birdfeeders.

Look at the paint box color gardens (pages 100–101) for authentic Monet color and planting scheme ideas. Remember that plants in containers must have good drainage and that they depend on you for consistent watering and extra organic food. No matter what, grow something! And enjoy cultivating your relationship with nature, even in a small space.

1. OBELISK WITH CLEMATIS

A simple structure made from three bamboo poles is planted in a large terra cotta pot with a white *Clematis montana*. You could use a metal obelisk with four legs, which would last longer. Monet used metal obelisks for his roses and bamboo, and for red climbing nasturtiums in front of his house. For a balcony, try this structure with annual vines or even beans and peas, and save space by gardening vertically.

2. MONET'S UMBRELLA ROSE *TUTEUR*

This rose is a small climbing variety grafted onto a rose standard trunk. Plant when dormant, and then place this special armature, which comes apart, around the rose. As the rose matures, train the branches to grow on the outside of the structure, tying them down with covered garden wire as needed. The standard tea roses are also lovely and not as difficult to maintain. Roses can be underplanted with striking blue campanulas, aubrietas, or violas.

3. ESPALIERED APPLE TREE

This espalier style is called a double cordon, but there are many other styles. This one works well on a balcony, along a wall, or, as in Monet's garden, around a lawn to create a blooming split-rail fence. The trees will need support from bamboo poles, a strong wire, or wood rails. As they grow, check to make sure their ties are not too tight. Prune annually around mid-August, shortening all side shoots from the main stem to three leaves. You will enjoy both flowers and fruit.

4. FLOWERING ARBOR

Monet used arches—sacred symbols in many cultures—throughout his gardens, including a series of wide arches down the Grande Allée for a tunnel effect, and connected arches over a sitting area near the pond. Single arched arbors, like this one that is covered with roses, can be used on pathways, and they add much charm over a gate or garden entrance. Plant a climbing rose at the base and train it to weave around and over the arbor. Keep thornier canes pruned to prevent them from snagging passersby.

5. POTTED PLANTS

A. Spring: Pink tulips planted with blue forget-me-nots. Plant bulbs in the fall and forget-me-nots when the soil thaws.

B. Summer: Geraniums in pink or red were among Monet's favorites. Plant after killing frosts are over; in mild climates they add beauty all year. Trim to keep from getting leggy. They are easy to propagate from cuttings.

C. Autumn: Dahlias and nasturtiums are a must for a Monet fall garden. A broad variety of dahlia tubers is available at specialty nurseries, and they can be planted around mid-May; miniature dahlias can be found at the nursery in 6-packs or 4-inch pots. Plant nasturtium seed when you plant the dahlias.

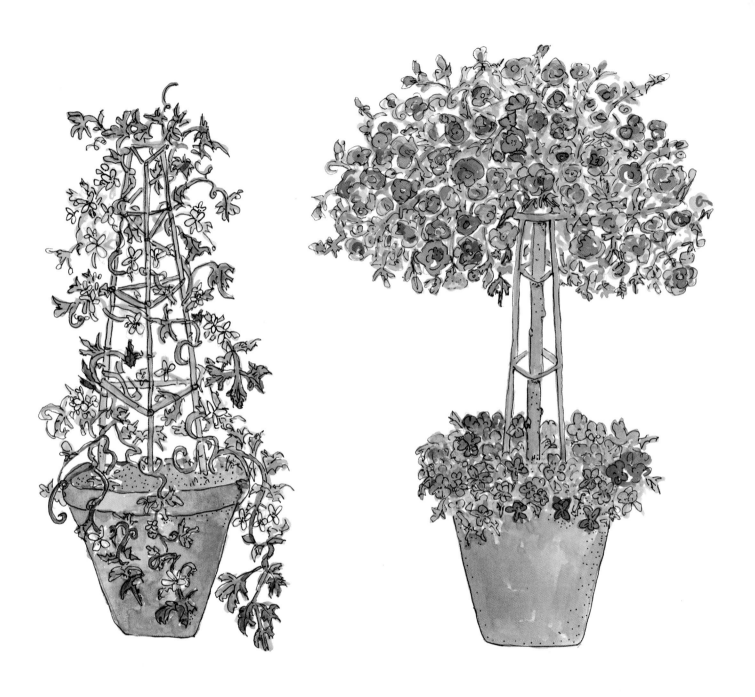

2. MONET'S UMBRELLA ROSE TUTEUR
UNDERPLANTED WITH BLUE VIOLAS

1. OBELISK WITH CLEMATIS

1. OBELISK WITH CLEMATIS

2. MONET'S UMBRELLA ROSE *TUTEUR*
UNDERPLANTED WITH BLUE VIOLAS

3. ESPALIERED APPLE TREE

4. FLOWERING ARBOR

5. POTTED PLANTS

**A. SPRING: PINK TULIPS WITH
BLUE FORGET-ME-NOTS**

B. SUMMER: GERANIUMS

**C. AUTUMN: DAHLIAS
AND NASTURTIUMS**

4. FLOWERING ARBOR

3. ESPALIERED APPLE TREE

5. POTTED PLANTS

C. AUTUMN: DAHLIAS
AND NASTURTIUMS

B. SUMMER: GERANIUMS

A. SPRING: PINK TULIPS WITH
BLUE FORGET-ME-NOTS

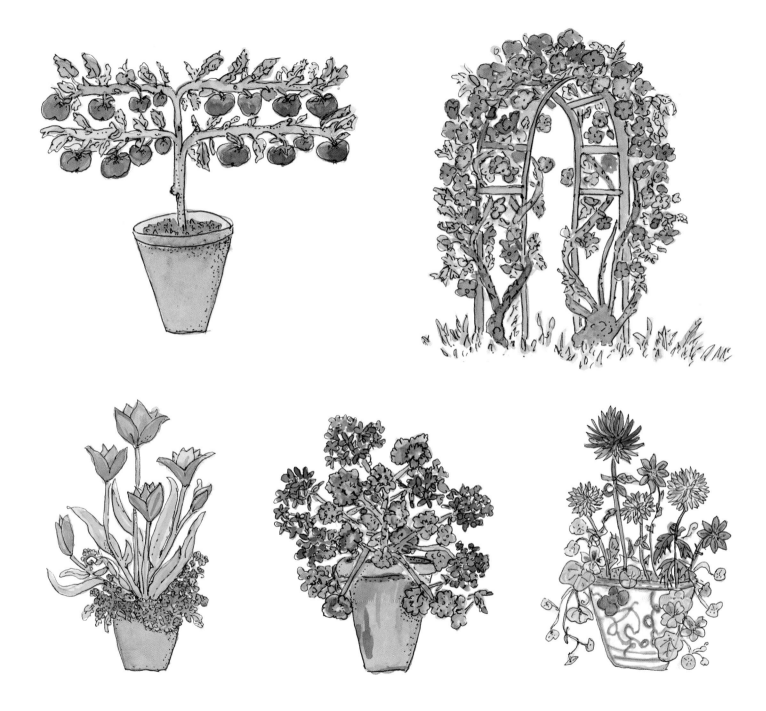

The Paint Box Plantings

The garden as a celebration

Paint box plantings were described by Arsène Alexandre in 1901: "Indeed, what is most remarkable about Monet's garden is not the plan but the planting, a play on words that nevertheless describes the principle behind these floral fireworks. The garden is divided into tidy 'squares' like any truck garden of Grenelle or Gennevilliers. Substitute flowers for carrots and lettuce, in rows just as close together, and you can work wonders—if you know how to play the floral almanac like a keyboard and are a great colorist . . . Monet wants as many flowers in his garden as a space can hold. He also wants, perhaps above all, his flower palette before him to look at all year round, always present, but always changing."

For Monet, color and how it relates to light were the key focus of his gardening plans, and the designs presented here rely on some of his favorite color combinations in different seasons. Techniques include overplanting bulbs with annuals for spring, or dahlia tubers with perennial asters for autumn; sowing wildflower seed with cultivated plants; and tying everything together with border plants—perhaps a lavender hedge that integrates the overall design. A trellis can be added to bring color up high. (Monet grew *Clematis montana* that resembled lace curtains blowing in the breeze over the flower beds; see figure 1, page 99.) This series of small beds can be adapted for cut flowers, children's gardens, herbs, or vegetables.

The first design is a potager, a kitchen garden for growing your own food. The designs can be adapted to your taste, and vegetables can be combined with flowers. The aubrietas used for edging can be replaced with parsley, chives, or edible flowers like nasturtiums, violas, or calendulas. The lavender hedge could be replaced with culinary rosemary.

The second design emphasizes the use of color. There are planting schemes for spring and summer or autumn. Seasonality depends on where you live, so it will need to be adjusted accordingly. These color combinations can be used in containers, perennial borders, or flower beds of different sizes.

When establishing your garden space, consider the topography. Monet's flower garden has a slight slope from the house to the bottom of the garden, where it ends with a rose-covered stone wall and the road. This helps create a forced perspective with the trellises and arches. When using an arch, think about the view you want to frame, what you want to grow on it, and be sure to secure it so wind will not blow it over.

PREPARING THE BEDS:
In these designs each bed is 5 feet long and 2½ feet wide. You will need to make adjustments to suit your garden. Each bed can be laid out with string and stakes at the corners. Path material can be gravel, like in Monet's gardens, or wood chips, grass, or a hardscape like decomposed granite or brick. Raise the beds 3 to 6 inches high by digging the earth with a spading fork to lighten and aerate the soil, adding organic matter like compost, well-rotted manure, or leaf mold as you do this. These beds can also be constructed with wooden frames to

raise the beds even higher, making it easier to garden. Aviary wire can be laid down to prevent gophers from coming up into the beds; rich, well-drained soil can be added to the boxes. This geometric design requires patient layout and preparation but will be established for many years to come.

PLANTING THE BORDERS:

Plant a border of mauve aubrietas around each bed (you will need about 14 small plants placed 12 inches apart). This will help keep the soil in place and create a distinct, pretty edge. Aubrieta is the edging perennial Monet used, but others can be substituted. At the inner end of each bed, plant lavender to create a unifying *allée* down the central path.

Plant *Clematis montana,* a small white-flowering variety with vigorous, rampant growth, for covering a large trellis in the fall in a mild winter area; otherwise plant in spring. Clematis needs rich, well-drained soil. It prefers to get at least 6 hours of sunlight, but its roots must be kept shaded. Many gardeners protect the roots with a stone or a clay roofing tile until established.

PLANTNG THE KITCHEN GARDEN:

Monet planted his vegetables according to an old tradition of grouping root crops in one area and leaf vegetables in another. Mix and match to your tastes and needs.

Beans and peas can be grown on tepees made from three bamboo poles tied together. Most vegetables can be sown directly in the ground after killing frosts. For early crops, seeds can be started in cold frames, greenhouses, or in a sunny window. Seedlings can also be bought for transplanting. Careful watering of seeds, thinning of tiny seedlings, and using netting to protect them from birds will help them get established. Rotating crops, adding compost, and replanting after each harvest will provide the best yields. Look at specific seed directions and vegetable books for details. Growing some of your own vegetables will bring you into a close relationship with your garden and the seasons, and provide you with delicious, healthy food. It is one of the most rewarding activities to share with your children, family, and friends.

PLANTING THE COLOR STUDY GARDENS:

Spring

Plant bulbs in each bed according to the type and colors called for below. Use violas, primroses, or English wallflowers to overplant the bulbs. There are two different times for planting, depending on your climate. Where winter freezing is common, plant violas, primroses, and English wallflowers outdoors in early spring over your bulbs. In regions with warm or mild winters, those flowers can be planted at the same time as the bulbs to provide color over the winter. Seed of English wallflowers and violas can be sown directly.

Plants needed:

BED 1: Red and Blue

Choose 24 red tulips (12 Darwin hybrids and 12 of a later-blooming variety will lengthen the blooming time). Plant 9 to 12 inches deep, 4 to 6 inches apart; add bonemeal to the planting hole. Plant 24 biennial blue forget-me-not plants, which will overwinter in most areas, above the bulbs. Annual forget-me-not

seed can be planted in spring when the ground can be worked.

BED 2: Yellow and Blue
Choose 50 to 100 bluebell bulbs, depending on how close you want them. Plant 3 inches deep and 4 to 6 inches apart in early fall; add bonemeal to the planting hole. They are lovely naturalized in lawns and under trees in woodland drifts; they will colonize and spread over time. Plant 30 yellow primroses or violas over the bulbs in fall or spring according to your climate. Another combination to consider is yellow daffodils or tulips with blue violas, or yellow daffodils mixed with the bluebells. If you have children in your life, they'll enjoy helping with the planting.

BED 3: Red and Yellow
Plant 18 to 24 yellow- and red-striped Rembrandt tulips in the fall. Overplant with red primroses. Monet loved to be greeted with these bright tulips after a long, cold winter.

BED 4: Blue with Gold and Orange
Plant 24 Wedgwood blue Dutch irises 4 inches deep and 4 inches apart. The bulbs look like pointed onions; plant with point facing up, after adding bonemeal to the planting hole. Plant gold, yellow, and orange English wallflowers over bulbs in fall or early spring.

Summer/Autumn
BED 5: Blue and Yellow (late spring/early summer)
Plant 10 to 12 blue delphiniums, as root stock or small plants, interspersed with 10 yellow leopard's banes, with the taller delphiniums toward the middle and the shorter leopard's banes near the edges. In areas where leopard's bane goes dormant in the summer, *Coreopsis grandiflora* can be substituted.

BED 6: Gold, Orange, and Purple
Choose 3 yellow *Helianthus* sunflowers (*H. multiflorus*), 3 purple Michaelmas daisy asters, and 3 orange cactus-flowered dahlia tubers. Plant with bonemeal and blood meal after the last frost. The plants will bloom from August until first frost. Plant in May for late summer and autumn bloom. All make wonderful cut flowers.

BED 7: Red and Orange (for late spring/early summer)
Plant 8 red Oriental poppies and then sow the bed with red French poppies and orange California poppies. These blazing colors echo the yellow and red Rembrandt tulips with red primroses from spring.

BED 8: Pink
Plant 5 soft pink perennial phlox with 6 single-flowered hollyhocks in pink and burgundy and 6 cosmos in white and pink. The cosmos and hollyhock seed can be sown directly if desired.

MORE OF MONET'S FAVORITE COLOR COMBINATIONS:
Spring
Daffodils and bluebells, yellow tulips overplanted with blue violas
Plumbago auriculata with blue morning glory (*Ipomoea*) flowers

Golden chain trees

Yellow *Helianthus*

Masses of purple, mauve, and lilac irises

Wisteria and lilac, with yellow roses such as the single 'Mermaid'

Summer/Autumn

Golden *Helianthus multiflorus* sunflowers towering over masses of asters in lavenders, purples, and mauves, with some whites and pinks in the cool lavender tones

Fruit trees abundant with plums, apples, and pears

Roses, the last blossoms mixed with some vermilion red rosehips

Hollyhocks and foxgloves

Masses of blue delphinium

Poppies in bright vermilion to shades of striking slate gray, in lawns

Verbascum, yellow to purplish pink

Gladiolus, small-flowered kinds in pink, coral, orange, white, and red

Dawn/Sunset Colors

Roses in soft yellow, coral, pink, and salmon. Lavender makes these colors glow more, so if wisteria, lilac, or, later, asters are blooming nearby, the effect will be like the dawn sky next to the sunrise. Lavender colors glow at the end of the day, but they recede at night completely.

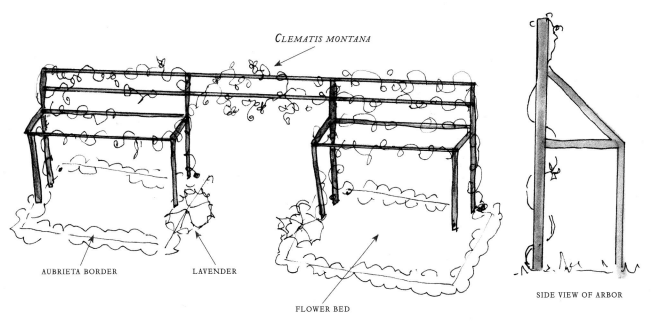

Fig. 1. Arbors can be added over the flower beds.

The Paint Box Plantings
A Kitchen Garden

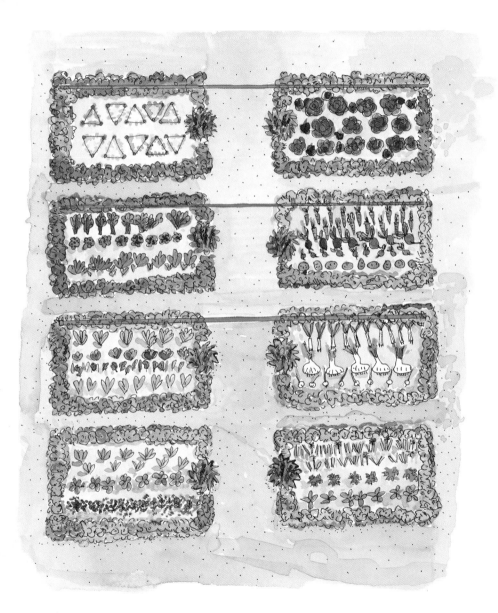

1 AUBRIETA BORDERS
2 LAVENDER
3 TRELLIS WITH
 Clematis montana

A LIMA BEANS AND SWEET
 PEAS
B RED CABBAGE
C CHARD, BROCCOLI, AND
 SPINACH
D CARROTS, BEETS,
 RADISHES, AND POTATOES
E LETTUCES AND ENDIVE
F LEEKS, GARLIC, AND PEARL
 ONIONS
G SAGE, THYME, OREGANO,
 AND OTHER HERBS
H CHIVES, TARRAGON,
 PARSLEY, AND ROSEMARY

1 AUBRIETA BORDERS

2 LAVENDER

3 TRELLIS WITH
Clematis montana

A LIMA BEANS AND SWEET
PEAS

B RED CABBAGE

C CHARD, BROCCOLI, AND
SPINACH

D CARROTS, BEETS,
RADISHES, AND POTATOES

E LETTUCES AND ENDIVE

F LEEKS, GARLIC, AND PEARL
ONIONS

G SAGE, THYME, OREGANO,
AND OTHER HERBS

H CHIVES, TARRAGON,
PARSLEY, AND ROSEMARY

The Paint Box Plantings
Color Study Gardens by Season

The Blooming Mirror

Water to reflect the sky and the passing clouds, catch the light, and invert the landscape

Bringing water into our gardens creates a place for reflection and a new habitat for plants and visiting birds. Whether big or small, the water garden offers an opportunity to experiment with different types of plants and create your own oasis, no matter where you live.

This design starts with a circular galvanized metal stock trough from a feed or farm supply store. Troughs come in both circular and oval forms of various sizes; most are about 2 feet deep. Find a sunny, level place in your garden and determine the size that feels right. Paint the interior black for better reflection, using a waterproof, nontoxic paint. To mark where the pond will be installed, place a wooden stake in the ground in the center of the designated space and tie a string to it (the string should be a bit longer than half the diameter of the circle to allow room for tying at each end). Fasten a second pointed stake to the other end of the string and, with the string taut, walk around the outside perimeter, dragging the pointed end of the stake in the soil to etch the pond's outline as you go; this can be marked afterward with nontoxic spray paint. Dig the hole slightly deeper than the depth of the trough and level the bottom; adding a layer of sand can make this easier. With the help of a friend or two, drop the trough into the hole. Backfill with extra soil to fill any gaps around the edges. You may

choose to place flat stones or bricks around the edges as well—mortar is not necessary, as plants can grow in the cracks—or you can just allow plant material to grow over the edges for a less formal look. You could also install the trough water garden as an aboveground feature, adding a bench or other sitting area nearby. Preformed black plastic pond liners are readily available, as are fish-grade PVC waterproof pool liners for custom-dug ponds. These are wonderful for more natural-looking ponds but entail more work and expense.

A submersible recirculation pump will be needed to keep the water fresh. Place the pump in the pond on a brick or concrete block so that the motor will be above the water (have the wiring done by a professional). The cord can be hidden under a stone, a plant, or another decorative object. All the water in the pond must be aerated every 24 hours, and this can be accomplished with a small fountain, an aquarium bubbler, or a small waterfall.

The pond should be stocked with two kinds of water plants: aerating grasses that float beneath the surface and flowering plants such as water lilies and water irises. Aquatic plants can be planted in special open-sided plastic containers (such as laundry baskets). For your water irises, choose Siberian, Japanese, or yellow flag. Plant in heavy clay soil, adding rock mulch to hold down the plants. Place plants according to color and the design you've chosen. You may want some of the edging plants to be higher; these can be set on concrete blocks. Then put on your boots and get the hose! Begin by filling the pots to saturate them thoroughly so they won't float. After the first few days the surface may have

to be cleared of any floating debris, but soon your pond will settle down and begin to grow.

Add fish and aquatic snails to keep everything in balance. Mosquito fish can be obtained from your local county mosquito abatement district. Check the back of this book for more resources.

Planting wisteria on an arbor by your pond will echo another familiar feature of Monet's garden. On a wooden or metal trellis, 5 feet long on each wing and at least 2 feet wide and 8 feet high, plant wisteria in the middle, training it across the top.

The other plants in this plan include a cluster of rhododendrons in red, pink, and deep purple; azaleas in pink, white, and mauve on either side of the wisteria arbor; and tree peonies in pink and white near the bench. Ferns can be planted around the paths. Monet liked to plant peonies with both foxgloves and Oriental poppies in pink, white, and mauve. Other plants he would have used are hydrangeas (blue only), blue agapanthus, and orange daylilies to set off the colors in the pond. A clumping bamboo would be another element to consider. If your pond is set in a hardscape, these plants can all be in containers around it.

If you have room for a weeping willow, Japanese flowering cherry, or crab apple, it would be a lovely addition for scale and year-round interest and reflection. Be aware that falling leaves can create extra litter in the pond.

Unless you have a natural pond and plants can be placed directly in the moist soil at the edge, they will be in containers set on concrete blocks submerged in the water, as noted above. All edge plantings will create reflections, doubling their beauty.

In Monet's gardens, pinkish-beige pea gravel is used for the paths. This is clean and requires little maintenance, and its color is warm and neutral. Wood chips would be an inexpensive rustic choice. Some gardeners may prefer a path of brick or stone; if you choose one of these, consider setting the pavers in sand so that drainage will be optimal and plants can grow in cracks between the bricks. A lawn path is another alternative, but it requires more maintenance and water.

The bench is an important feature that invites you to pause, reflect on the beauty of the garden around you, and dream. This design indicates a 5-foot-wide arch for two climbing roses, one planted on either side, to provide a fragrant backdrop to the bench.

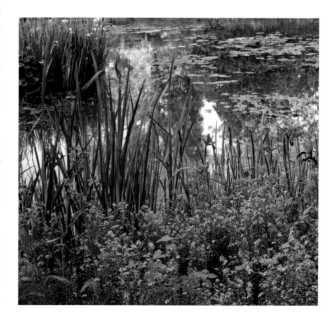

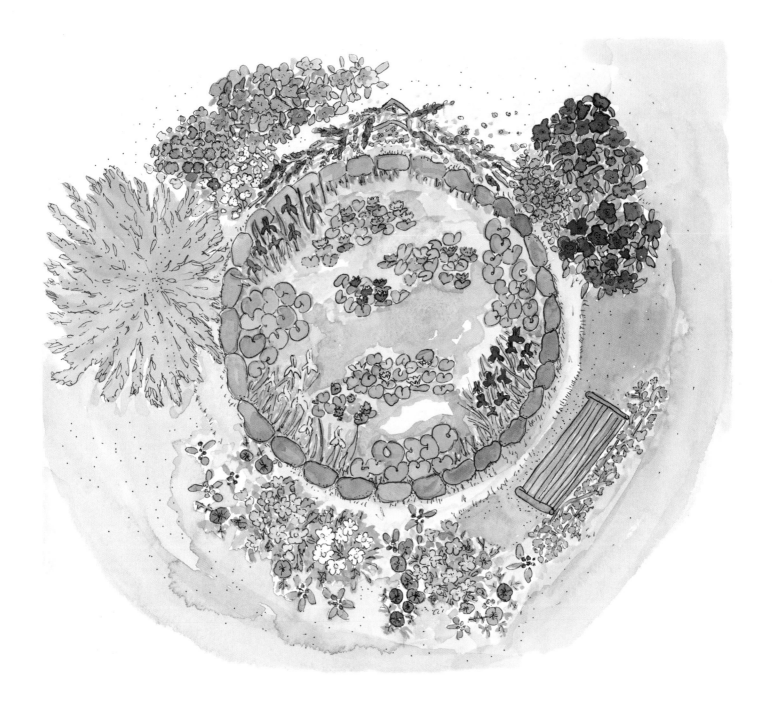

The Blooming Mirror Water Garden

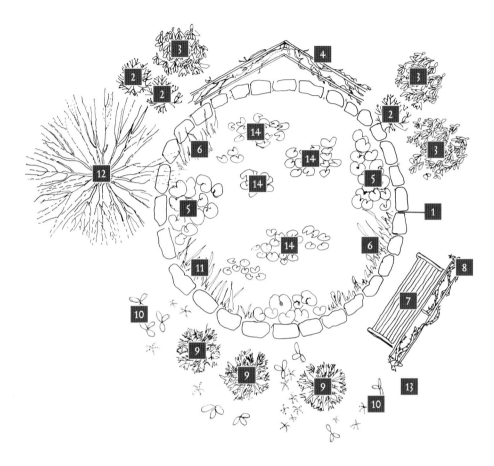

1 10-FOOT CIRCULAR GALVANIZED METAL STOCK TROUGH WITH STONE EDGE

2 AZALEAS IN PINK, WHITE, AND MAUVE

3 CLUSTERS OF RHODODENDRONS IN PINK, DEEP PURPLE, AND RED

4 PURPLE WISTERIA

5 COLTSFOOTS

6 PURPLE SIBERIAN IRISES

7 BENCH WITH 5-FOOT-WIDE ARCH

8 PINK CLIMBING ROSES

9 TREE PEONIES IN PINK AND WHITE

10 FOXGLOVES AND ORIENTAL POPPIES IN PINK, WHITE, AND MAUVE

11 YELLOW FLAG WATER IRISES

12 WEEPING WILLOW, JAPANESE FLOWERING CHERRY, OR CRAB APPLE

13 PINKISH-BEIGE PEA GRAVEL

14 WATER LILIES

PLANT CULTIVATION

APPLE
Malus domestica

Deciduous fruit tree. Very adaptable, many delicious varieties available. Most need 900–1,000 hours of temperatures at or below 45°F/7°C to set fruit, although there are low-chill varieties (100–400 hours). Dwarf apple trees take up little room and bear fruit at a younger age; best for espaliers and for containers, but not as reliable in the coldest regions. Provide good humus-rich soil with good drainage, extra care in feeding and watering. Plant in full sun; prune late in the dormant season. Espaliers require support; train branches to follow desired pattern, pruning out excess growth. Many varieties to choose from; select one best for your climate, needs, taste.

ASTER

Perennials in the daisy family, easy to grow in a sunny spot. Plants range in height from 6-inch-high mounded varieties to bushy ones 6 feet tall. Most asters bloom abundantly in summer and fall, providing rich shades of deep purple, bright blue violet, and ruby crimson. They also come in soft blues, lavender, pink, and pure white for light, airy spots in the summer garden. Divide and plant clumps in late fall or early spring, using vigorous outside growth; discard the unproductive centers of the plant. Asters will respond with more flowers if they are planted in rich soil and receive regular water.
Aster frikartii ('Wonder of Stafa'). This outstanding hybrid grows about 2 feet tall; profusely covered with lavender blue flowers from May to October. Zones 6–9.
Aster novi-belgii. 3- to 4-foot perennial known as Michaelmas daisy. Well-branched plants carry large clusters of flowers in white, pink, rose, red, and shades of blue, violet, and purple. Zones 6–9.

AUBRIETA
Aubrieta deltoidia

This perennial grows in compact mounds 2 to 6 inches high, 12 to 18 inches across, and thrives in full sun. Small gray-green leaves are covered with tiny pink, lavender, or violet flowers in April and May; aubrieta's foliage provides the main interest at other times of the year. Plant in spring by seeds or transplants; will tolerate semi-dry gardens when established. Monet used aubrieta effectively for edgings in long flower borders. Hardy in Zones 4–8.

AZALEA (see RHODODENDRON)

BAMBOO
Phyllostachys

Actually a giant grass with large, woody stems that lives for many years. Running underground stems grow rapidly, sending up vertical shoots and creating large groves. There are hardy and tropical varieties; Monet grew many varieties of bamboo, but he favored *P. nigra* for its violet-black streaks. Green stems generally turn black in the second year. Plant in rich soil with organic amendments in a site where summer heat or winter cold is avoided. Mature culms will send up new shoots and grow to mature height in one month. Size depends on variety, but all are evergreen and can adjust to full

or partial sun after they are established. Some summer water is beneficial. Zones 8–10; some species are also hardy in Zones 5–7.

BLUEBELL (Squill)
Scilla bifolia or S. sibirica

Blooms very early, at the same time as snowdrops, Christmas roses, and winter jasmine in Monet's garden. Blue starlike flowers appear on clusters of stems 4 to 8 inches long. Plant these small bulbs in the fall; they need good drainage. Most effective planted in informal drifts 2 to 3 inches deep, 3 to 4 inches apart, in full sun. *S. peruviana* is a better choice for warmer climates. Blooms May to June. Zones 4–9.

CALIFORNIA POPPY
Eschscholzia californica

Perennial usually grown as an annual. Gorgeous golden-orange satiny-petaled single flowers. Plant in fall in mild-winter areas and early spring in colder regions. Sow seeds in place with some sand; they do not transplant well. Keep soil moist until seed germinates. Allow to reseed year after year or collect seed to plant in other areas.

CHERRY TREE (Japanese flowering cherry)
Prunus serrulata

There are many varieties of this beautiful spring-blooming tree. Heights range from 20 to 40 feet. All require full sun and light, fast-draining soil (not clay); can tolerate dry spells but prefer moderate summer water. The best times to transplant are autumn or early spring. Most varieties have pink blossoms, although white-flowering ones are also available. Shapes vary from the tall, narrow, columnar *P. s.* 'Amanogawa' to the gracefully weeping *P. s.* 'Pendula'. Place flowering cherries in your garden according to their growth habit. Zones 5–8.

CLEMATIS (Anemone clematis)
Clematis montana

This deciduous vine needs at least 5 to 6 daily hours of sunlight to produce the most flowers. Plant next to trellis, arbor, obelisk, or fence, give support for twining; keep mulched and watered. Plant in large hole, up to 2 feet wide and deep, in rich, fast-draining soil mixed with generous amounts of organic matter such as compost. Cut new plants 6 to 12 inches from base when you transplant. Feed once a month with complete liquid organic fertilizer during the growing season. This is a vigorous grower up to 20 feet, perfect for a large arbor; a smaller variety would be better for a container. Many varieties, colors, sizes, flowers, and blooming times available; some are evergreen. Check which is best for your climate.

COTTAGE PINK
Dianthus plumarius

Perennial. Charming old-fashioned edging or border plant with loosely matted silver blue grasslike foliage. Monet edged his raised rose beds with cottage pinks. Dainty carnation-like flowers with 10- to 18-inch stems are single or double in pink, rose, or white with dark centers or pink edging. Flowers have an unforgettable spicy fragrance and are perfect for small bouquets. Blooms from June to October; thrives in full sun and light, well-drained soil. Plant in autumn or spring 10 to 12 inches apart. Avoid overwatering and cut spent flowers regularly. Zones 3–8.

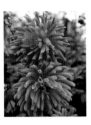

DAHLIA

Perennials grown from tuberous roots that resemble sweet potatoes; also grown from seed. Flowers come in a tremendous range of size, color, and flower shape. Although Monet preferred cactus dahlias, with their simple, fluted petals and 3- to 12-inch flowers, he also grew other types of dahlias from seed. Some of his favorite colors were crimson edged in gold, lilac, white, and coral with yellow tips. After danger of frost has passed and the ground has warmed up, plant tubers in full sun in soil rich with organic matter. Place 3 feet apart in 1-foot-deep holes. Stake plants, taking care not to injure tubers. Water deeply and keep moist. Tubers may be overwintered in the ground in Zones 9–10 (8 with protection); elsewhere, dig up before freeze and store tubers in frost-free place.

DAYLILY
Hemerocallis

Perennials with tuberous roots growing in large, spreading clumps with arching, sword-shaped deciduous or evergreen leaves. Spectacular lilylike flowers in a wide range of colors, including cream, yellow, coral, pink, salmon, bronze, and red. These vigorous, pest-free plants grow in almost any kind of soil in full sun or partial shade, but flowers will last longer if given afternoon shade. Water deeply while blooming, fertilize in spring and midsummer, and divide and plant in early spring or late fall. Zones 4–9.

DELPHINIUM

Perennials with spectacular flower spikes atop stems that sometimes reach up to 8 feet on modern hybrids. Most gardeners seem to favor delphiniums in shades of blue, from pale sky blue to deep violet blue, but delphiniums are also available in pink, lavender, and white. The older, dark purple–flowered candle delphinium (*D. elatum*) is probably the species Monet grew in his borders. In mild, cooler climates, Pacific Strain delphinium hybrids will bloom once in spring, die back, and bloom again in early fall with a smaller spike if plants are fertilized. Delphiniums can be grown from seed, nursery transplants, or from rooted divisions of clumps planted in spring or fall, depending on your climate. Choose a place that receives full sun (or light shade in hot climates), and provide deep water when the plants are developing and flowering. Hardy in Zones 3–7, but treat as a hardy spring annual in Zones 8–10.

DUTCH IRIS (see IRIS)

FERN

A large group of perennial plants grown for their light, airy, woodland feeling in the garden. Ferns are easy to grow if given light or partial shade and cool, moist conditions in soil rich in humus. It is best to plant them in spring, after all frost, or in autumn; avoid planting in hot weather. Heights range from 6 inches to over 6 feet. When selecting ferns for your garden, check with nurseries or with specialists who can recommend those kinds best suited to your climate and growing conditions. Following are several hardy ferns that Monet grew:

LADY FERN (*Athyrium filix-femina*). Grows 3 feet tall, with finely divided fronds. Looks delicate, but will tolerate fairly dry soils. Zones 3–8.

AUTUMN FERN (*Dryopteris erythrosora*). Grows 18 to 24 inches tall, with new bronze growth that matures to dark green, then turns bronze again in autumn. Zones 5–9.

OSTRICH FERN (*Matteuccia struthiopteri*). Reaches 5 to 6 feet in height. Needs half to full shade in rich, moderately moist soil. Zones 5–9.

SHIELD FERN (*Polystichum braunii*). Green, leathery, spine-tipped fronds are 18 to 24 inches long. Zones 6–8.

FORGET-ME-NOT
Myosotis scorpioides

Perennial often used as an annual. Known for its tiny rich blue flowers with yellow centers; blooms freely from spring through summer. Effective massed together, either planted over tulips, woven into perennial borders, or left to naturalize in woodlands or where it can self-sow. Flowers most profusely in partial shade with ample water. Annuals must be planted in spring, perennials in autumn or spring. *M. sylvatica* (often sold as *M. alpestris* 'Indigo Compacta') is a biennial which can be planted over a bulb bed in the autumn and will winter over in most climates. These tiny clear blue, white-eyed flowers bloom and reseed over a long season, beginning in late winter or early spring and lasting until the weather is hot. Forget-me-nots also come in pink or white. Zones 3–8.

FOXGLOVE
Digitalis purpurea

A favorite old-fashioned biennial or perennial for shaded or partially shaded borders and woodland type settings. Magnificent flower spikes with large bell-shaped flowers attractively spotted in the throat reach a minimum height of 4 feet. Colors range from white and shell pink to deep rose, lavender, and purple. Blooms from May through September in full sun to light shade in moist, rich soil. Plant by seed in spring or set out plants in fall for spring bloom. Foxglove freely self-sows. Zones 4–9.

FRENCH POPPIES
Papaver rhoeas

Flanders poppy, or *coquelicot,* is a summer annual wildflower in the hills of France. Monet loved it for its pure color and simplicity as well as the way light would go through the petals. Flowers are 2 to 3 inches across and can easily be grown from seed mixed with fine sand. Sow seed successively after frost or in fall in mild climates for blooms from spring into summer. Choose a sunny spot with good drainage; feed lightly until established. Remove seed heads to prolong bloom, allowing some seed to mature and self-sow for next year.

GERANIUM (common)
Pelargonium × hortorum

A highly favored, widely used tender perennial, often used as an annual in cold climates. Monet enjoyed combining red and pink single-flowered geraniums in a bed bordered with old-fashioned pinks. Popular for containers, window boxes, and flower beds; easily propagated by cuttings; can be overwintered as a houseplant. Plants grow 14 to 20 inches high. Round dark green leaves have velvety texture. Colors include white, pink, salmon, and red. Plant in full sun in spring after last frost in rich, well-drained soil. For best bloom, water and fertilize regularly and remove spent flowers and leaves. All zones as a summer bedding plant or houseplant; Zones 9–10 as a shrubby perennial.

HOLLYHOCK
Alcea rosea (Althaea rosea)

Monet preferred the old-time, single perennial variety that can reach 9 feet. Colors include white, yellow, coral, pink, red, and crimson. Blooms in summer if planted the preceding autumn in full sun. Give regular watering,

but avoid wetting foliage, which is susceptible to rust. Zones 3–9.

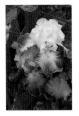

IRIS
Iridaceae

These perennials are grown from bulbs and rhizomes.

BEARDED IRIS (FLEUR-DE-LIS). A fragrant, perennial old-fashioned bearded iris (formerly called German iris, although not native to Germany) has 9-inch-tall lavender purple flowers on 2- to 3-foot stems from late spring to early summer. The almost indestructible rhizomes form dense clumps that choke out weeds and must be lifted and divided every 3 to 4 years. Monet planted thousands of these irises in 3-foot-wide monochromatic borders with striking results. Plant rhizomes in early spring or autumn in rich, well-drained soil in full sun. Provide ample water, especially while in bloom. Zones 4–9.

DUTCH IRIS. Slender, delicate, leaf-shaped flowers, 3 to 4 inches across, stems 18 to 24 inches tall. Colors include white, yellow, and bronze, as well as blue, mauve, and purple. Plant the small bulbs 3 to 4 inches deep in a sunny location in autumn. Provide regular water. Dutch irises bloom earlier than most bearded irises, in late spring or early summer. Excellent for container culture and cutting. 'Wedgwood', light clear blue with a yellow blotch, was Monet's favorite variety. Zones 5–8.

JAPANESE IRIS (*Iris ensata*). Spectacular irises, with flowers 6 to 9 inches across with wide reflexed, heavily veined petals, appear in June and July. Colors range from pure white to lavender and blue violet. Best grown in moist, humus-rich, acid soil in full sun. Plant rhizomes in early spring or autumn 2 inches deep and 1½ feet apart; or plant up to 3 per 12-inch container. Likes moisture;

can be planted alongside the edge of a pond or, during the growing season, in containers submerged halfway to the rim. Remove containers after the growing season. Mulch in winter; good cut flower. Zones 5–9.

SIBERIAN IRIS (*Iris sibirica*). Graceful flowers shaped like Dutch irises bloom on 2- to 3-foot stems after bearded irises have faded. Colors include pale and deep blue, purple, red violet, and white. Can be grown in perennial borders in full sun if given moist soil high in humus. Plant rhizomes in spring or from divisions in September through October; well-established clumps bloom best. Zones 3–9.

YELLOW WATER IRIS (*Iris pseudacorus*). This hardy perennial iris grows 5 feet tall; spectacular 3-inch bright yellow flowers on stems 1 to 2 feet above the foliage appear in May and June. Plant rhizomes in spring or fall. Full sun to light shade. Thrives in shallow water (to 18 inches deep); can also be planted on an island in a pond or along water's edge. Zones 3–9.

JAPANESE FLOWERING CHERRY
(see CHERRY TREE)

JAPANESE IRIS (see IRISES)

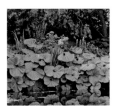

JAPANESE COLTSFOOT
Petasites japonicus

This hardy creeping herbaceous perennial is dormant in winter. An invaluable plant for cool, shady sites near water's edge where a dramatic, large-leaved ground cover or accent plant is desired, it has distinctive heart-shaped leaves that can reach 16 inches in width with a white, woolly underside and dull dark green surface. *Petasites* are about 1 foot in height and can spread up to 6 feet. The early spring flowers are treasured by flower arrangers; the stem is grown as a vegetable in

Japan. Plant in spring or fall in the moist soil along the edge of water. Zones 4–9.

LAMB'S EAR
Stachys byzantina
Hardy perennial, grown for its soft, thick, silvery, downy leaves on spreading 18-inch stems. A very attractive foliage plant; blends exceptionally well with blue, lavender, and dusty pink; also makes wonderful contrast with red. Purple flowers in summer can be removed to preserve the foliage. Plant in well-drained soil in spring after last frost. Sun to light shade, light summer water. Cut back frost- or water-damaged leaves in spring. Zones 4–9.

LEOPARD'S BANE
Doronicum cordatum
This perennial has bright yellow daisylike flowers that bloom in early spring on long stems. It is stunning planted with blue forget-me-nots and violas, or purple lilac with lavender tulips, as Monet did. The variety 'Magnificum' is a strong plant with bigger flowers. Good cut flower. Plant in spring after frost or in autumn. Grow in filtered light in good soil and give moderate water. Zones 3–8.

LILY OF THE NILE
Agapanthus praecox orientalis
Evergreen tender perennial related to amaryllis with as many as 100 clear blue flowers in clusters on each 4- to 5-foot stem. Straplike leaves grow in clumps. Thrives in loamy soil with ample water during growing season but will adapt to heavy soil and drought when established. Can bloom from spring into autumn in favorable conditions. Adaptable to sun or shade, but must be lifted and stored in cold-winter areas. Excellent container plant, beautiful by water; Monet grew it by his pond. *Agapanthus* 'Peter

Pan' is an outstanding dwarf variety with an exceptional numbers of flowers. Zones 7–10.

MICHAELMAS DAISY (see ASTER)

NASTURTIUM
Tropaeolum majus
A perennial in mild climates; otherwise used as an annual. The distinctive 2- to 3-inch round leaves and long-spurred flowers have a refreshing peppery fragrance and a flavor similar to that of watercress. Both can be used in salads. Flowers range from creamy white to yellow, gold, orange, red, and maroon. Easy to grow in well-drained soil and a sunny location where summers don't get dry and hot. Plant by seed in average to poor soil after frost. The trailing vines can creep up to 8 feet. Blooms all summer and fall until killed by frost. Adaptable, but benefits from some summer water. Perennial: Zones 8–9; annual: all other zones.

ORIENTAL POPPY
Papaver orientale
Monet planted these 4-foot-high perennials in beds on his lawns in great profusion, using varieties ranging in color from bright vermilion—with bold, contrasting black centers—to shades of striking bluish gray, pink, and coral. Flowers are 5 to 8 inches wide. Plants die back in midsummer and new growth appears in early fall; interplanting poppies with late summer–blooming plants helps to hide their fading foliage. Plant in early spring or fall in ordinary soil with good drainage. Give light watering and feeding until established. Zones 3–8.

PANSY (see VIOLA)

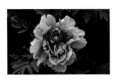

PEONY (Tree peony)
Paeonia
Deciduous 3- to 6-foot-tall shrubs with irregular branching habit need full sun. Leaves are large, deeply divided, blue-green to bronzy green. Flowers are very large and elegant with silky texture, up to 12 inches across. Monet preferred the single Japanese types to the heavy double European kinds. Many have the fragrance of old-fashioned roses. Colors include white, yellow, pink, red, lavender, and purple. Very hardy to cold, they bloom in early to late spring. Water regularly in summer. In fall plant deep in well-dug hole enriched with organic matter (avoid using manure near roots). Zones 4–8.

PHLOX (Summer phlox)
Phlox paniculata
This hardy perennial blooms profusely from midsummer to fall in full sun or light shade. The old-fashioned, sweetly scented flowers reach 24 to 30 inches in height. Where summers are hot, mulch around the plants to keep roots cool. Plant transplants in spring or by seed in fall; divide plants every few years, planting young shoots from outer edges of clumps in spring. Give regular water and average garden soil. Blooms in pure white, soft pink, red, and sky blue. Zones 3–9.

PRIMROSE (often called English primrose)
Primula polyanthus
Perennial used as an annual in hot climates. Bright green rosettes of leaves resemble small Romaine lettuce leaves. Charming 1-inch-wide flowers in bouquet-type clusters come in all primary colors as well as white, orange, and purple. Blooms from late winter through spring in moist,

shady garden with rich soil. In mild winters, transplants can be set out in fall for winter and spring flowers; in cold areas set out when ground thaws in spring. Zones 5–8.

RHODODENDRON (AZALEA)
DECIDUOUS AZALEAS. Exceptionally hardy types include the Exbury and Mollis hybrids, which grow 3 to 6 feet high. Colors include red, orange, pink, and white. Autumn foliage turns to brilliant orange, red, and purple; some are very fragrant. Plant shrubs in early spring while in flower (to see exact color) in deep holes mixed with peat moss and leaf mold. All azaleas enjoy moist, acid soil with excellent drainage; protect from summer sun. Zones 3–8.
EVERGREEN AZALEAS. Require moisture in the summer, filtered light, and acid soil. White, pink, and lavender flowers in May and June; Monet preferred shrimp red, pink, and pure white azaleas. Depending on variety, evergreen azaleas reach heights of 3 to 6 feet with equal spread. Plant in spring to check flower color. Zones 6–9.

ROSE
Rosa
Until the turn of the twentieth century, roses were available only in shades of white, pink, mauve, and red. In the early 1900s, the first hybrid tea roses of rich, pure deep yellow were available. Soon after, breeders could produce more vibrant colors like fiery copper and burning reds. Monet enjoyed the new varieties with these brilliant shades of color, but he favored the simple, single-flowered roses in shades of pink, yellow, salmon, and red. Rambling roses like 'Belle Vichyssoise', 21 to 24 feet long, wound around tree trunks at Giverny, blooming once a season with a profusion of small, scented flowers in long clusters. 'Mermaid', a single-flowered soft yellow rose, blooms for

a long period in mid-season; it was so favored by Monet that he grew it on a trellis under his bedroom window. Special iron trellises arching over the Grande Allée provided support for climbing roses of many colors. Ten-foot triangle-shaped pillars were garlanded with roses; umbrella-shaped structures supported standards topped with a miniature climbing rose grafted to the trunk and trained to shower gracefully downward.

Choose a site for your roses with at least 6 hours of sun each day, preferably morning light, which is cooler than afternoon sun. Locate roses away from large trees and shrubs, as they will compete for nutrients, water, and light. Use a raised bed for the excellent drainage essential for growing roses. You will have more varieties to choose from and less expense if you plant from bare root stocks when the ground thaws in the spring.

Dig a hole at least 30 inches wide that is deep enough to accommodate the roots. Add rich organic amendments to native soil, such as compost, leaf mold, or aged cow manure. If you live in a climate where the ground freezes solid in winter, make sure the bud union (where the stems have been grafted to the root stock) is 1 inch below the soil level; in milder climates, it should be above the soil level. Pat the soil firmly around the roots. Mound soil around the rose to make a basin; fill with water and allow the rose to settle in. Adjust plant if sinking has occurred.

Size and blooming times vary with variety, but roses generally bloom in summer, with some late spring and early fall flowers. Feed established roses 3 to 4 weeks after planting (bare root roses should be fed after groups of 5 leaflets appear). Mulch roses with 4 to 5 inches of organic material—bark, pine needles, straw, aged manure, or compost. Zones 4–10 (check particular variety for hardiness).

SIBERIAN IRIS (see IRIS)

SUNFLOWER
Helianthus multiflorus

A hardy perennial that grows 3 to 5 feet high—a splendid plant for late summer and autumn bloom. It produces hundreds of long-lasting, cheerful yellow gold daisylike flowers, excellent for cutting. Plant in spring or fall in well-drained soil. Requires full sun and moderate water while in growth period. Zones 3–9.

TREE PEONY (see PEONY)

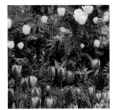

TULIP
Tulipa

Monet grew tulips of every color and hue to create striking color combinations. His favorites included:

DARWIN TULIPS. Large oval flowers on stately stems up to 2½ feet tall, with a color range from white to almost pure black, with all shades but blue in between. These tulips give the best show for display gardens.

PARROT TULIPS. Fringed petals with twisted shapes distinguish this unusual tulip; excellent for cutting.

RETROFLEX TULIPS. A group noted for its reflexed petals, much like lilies. Monet preferred a clear yellow.

REMBRANDT TULIPS. Distinguished by striped and mottled petals of contrasting colors.

Plant tulips in full sun in autumn 9 to 10 inches deep, instead of the usual 4 to 6 inches, to prolong blooming life over several seasons. The deeply planted bulbs will allow for overplantings of annuals and shallow-rooted perennials without disturbing the bulbs. Plant in well-drained, friable soil with bonemeal. Zones 3–9; tulips will bloom from late March to mid-May in Zone 6; early

and late blooming varieties will bloom at different times in different zones. Don't let the bulbs dry out while in bloom.

VEGETABLES

Can be grown from seed or from small transplants. Consult a vegetable gardening book for the varieties you would like to grow. All vegetables benefit from soil that is rich in organic matter and drains well. Double dig beds with compost and grow organically for the best results. Always grow organically to promote your health and the health of the earth. Making your own compost from garden trimmings, weeds, kitchen scraps, and manure is the best thing you can do for your soil. Keeping a worm box (vermicomposting) is another great way to improve soil and can be done even in an apartment. Vegetables can be grown along with flowers in "edible landscapes" or even in containers on a balcony. Whatever you can't eat can be frozen, canned, or dried for winter, traded with neighbors, or given to local food banks. Save the seed your plants produce to use next year. Be sure to plant flowers that bees like: this ensures that your vegetables are pollinated and makes your garden a haven for nature. Invite children to join you in planting, watering, harvesting, and feasting. Home-grown food was one of Monet's great joys.

VIOLA (or PANSY)
Viola cornuta, V. × wittrockiana

Annual with a wide range of colorful 2- to 3-inch-wide flowers in white, blue, deep red, rose, yellow, apricot, purple, and bicolors. Centers are sometimes blotched or striped with contrasting color. Plant by seed in July or August in full sun to partial shade in rich, moist soil. Transplant seedlings into cold frame for winter. Set plants out in spring; they can tolerate frost. In mild winters set out nursery plants in fall for winter and spring flowers. Hot weather will make violas leggy. Pinch plants and remove spent blooms to extend flowering period. Zones 3–9.

WALLFLOWER (English wallflowers)
Erysimum cheiri (was *Cheiranthus cheiri*)

Favorite old-time cottage garden perennial or biennial with sweetly scented flowers, 2 feet tall. Molten colors in rich shades of yellow, gold, orange, brown, coral, salmon, and burgundy are effective in large masses. Blooming in early spring, wallflowers are logical companions for tulips, Dutch irises, columbines, or lilacs. Locate in light shade to full sun in moist, well-drained soil. Sow seed in spring for bloom the next year, or transplant hardy seedlings in fall or early spring. Zones 6–10.

WATER LILY
Nymphaea

There are hardy and tropical water lilies. Both require at least 5 hours of sun but do best with a full day of sunlight. Plants sizes range from 6-inch miniatures to large ones over 4 feet across.

Hardy varieties can be grown almost everywhere. Flowers last 5 consecutive days in warm, sunny weather and bloom continuously through summer until first frost. Colors range from pure white to yellow, coral, pink, orange, rose red, and burgundy. Zones 3–10.

Tropical water lilies come in extraordinary colors, including amethyst blue, deep plum, lavender, and sunset blends of yellow, pink, and apricot. Tropicals must be planted after warm weather has settled in. Set plants in

tubs of rich, heavy soil; take the tubs out of the water in the winter and store where they won't freeze. These fragrant flowers will continue to bloom after frost has put hardy water lilies to sleep. Zones 3–10 (if used as annuals or stored over winter).

WEEPING WILLOW
Salix babylonica

Deciduous trees with graceful, pendulous, golden, whip-like branches mature to 30 to 50 feet with equal spread and a lovely weeping habit. Long, narrow, bright green leaves emerge in very early spring.

Willows require plenty of water and have invasive roots; best planted next to a pond or stream; can tolerate poor soil and poor drainage. Plant these fast growing trees in spring or fall in a site that receives full sun. Monet effectively used willows alongside his pond, where their graceful branches touched the water and their roots held the bank. Zones 3–9.

WISTERIA

Deciduous woody vines, usually very long-lived, with exceptionally beautiful flowers. Can be trained as a tree, shrub, or vine. Monet used wisteria in all forms: as a vine on the bridge and in front of his house, as a small tree by the pond, and throughout the flower garden. Plant from cuttings or grafted root stock in the spring; provide good drainage and ample water and fertilizer while plants are young. Mature plants will bloom better with less food and water in full sun but will adjust to filtered light. Zones 5–9.

CHINESE WISTERIA (*W. sinensis*). Flower clusters shorter (to 12 inches) than Japanese wisteria, but more showy because flowers bloom before leaves appear. Blooms earlier than Japanese wisteria.

JAPANESE WISTERIA (*W. floribunda*). Fragrant lavender to blue flowers bloom in 18-inch-long clusters; leaves divided into many leaflets. A white variety ('Alba') is available.

Monet combined both varieties of wisteria for extended blooming time. Mauve wisteria bloomed in profusion on the top trellis of the Japanese bridge, and white wisteria graced the lower spans of the bridge, providing breathtaking reflections in the water below.

YELLOW WATER IRIS (see IRIS)

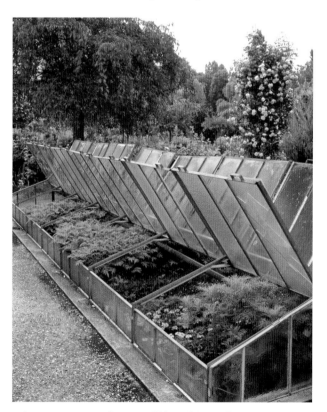

Like a miniature greenhouse, a cold frame helps seedlings get a head start on the growing season.

PLANTS USED BY MONET IN HIS GARDENS

The following list of plants used in Monet's original gardens has been gathered from several sources: Jean-Marie Toulgouat's garden plan, which appeared in Claire Joyes's book *Monet at Giverny;* an in-depth article by botanist and garden writer Georges Truffaut, who visited Monet at Giverny: "The Garden of a Great Painter" appeared in 1924 in the periodical *Jardinage;* an 1891 article by novelist, art critic, and fellow gardener Octave Mirbeau, Monet's close friend, titled "Claude Monet," published in the periodical *L'art dans les deux mondes;* and my own study of old photographs and talks with plant specialists. Unfortunately I have not been able to include a specific species for some of these plants because my research proved to be inconclusive. Occasionally I have chosen a variety that Monet may have used, according to the literary description and growing conditions required. However, when you choose plants for your garden, it is not as important to match Monet's species as it is to use ones that will grow and thrive in your particular environment. Always select a local native plant if you have the opportunity, as it not only will thrive best but also will become a habitat for the local pollinators such as butterflies, birds, and bees that are essential to the well-being of nature.

Some of the plants Monet used in his garden, such as plumbago, were very rare at the time, and yet they may be easily obtained these days. On the other hand, today it may be difficult to find many old-fashioned varieties of flowers and unhybridized plants. The Internet is a great way to research plants and nurseries.

THE CLOS NORMAND GARDEN

Spring Bulbs:

Galanthus nivalis. Common snowdrop. White.
Hyacinthus orientalis. Common or Dutch hyacinth. Blue.
IRIS. Dutch iris (so called because first hybridized by Dutch growers). Blue with a dash of yellow.
NARCISSUS. Daffodil. Monet preferred trumpet (large-cupped) varieties such as 'King Alfred' and shallow-cupped varieties like poet's narcissus (also called 'pheasant's eye'). Yellow or yellow and white.
Scilla bifolia. Squill, bluebell.
Tulipa. Tulip. Among the different types grown by Monet were Darwin (in all hues but blue), parrot, retroflex, and Rembrandt (with stripes and spotted colors).

Summer/Fall Bulbs:

CANNA. Reds, yellow, and orange.
DAHLIA. Monet especially liked cactus dahlias (with reflexed petals) and single-flowered varieties. All colors except blues.
GLADIOLUS. Varieties with smaller flowers and looser, more informal growth habit, such as *G. callianthus* (formerly called *Acidanthera bicolor*), grown in tall masses, were preferred by Monet.
JAPANESE LILY. Two of the most important Japanese species are *L. auratum* and *L. speciosum.* White.

Spring Perennials:

Aquilegia vulgaris. European columbine. Blues, yellow, and pink.

Aubrieta deltoidea. Aubrieta. Monet used this extensively as an edging plant for long flower borders; profusely flowering in violet to mauve, gray-blue foliage.

Doronicum cordatum. Leopard's bane. Clear yellow daisy-like flower with wildflower look.

Erysimum cheiri (formerly called *Cheiranthus cheiri*). Wallflower. Sweet-smelling. Golds, oranges, and deep mahogany.

Eschscholzia californica. California poppy. Luminous orange.

Helleborus niger. Christmas rose. Greens, white, and deep purple.

IRIS. Monet planted tall bearded irises (formerly called *I. germanica,* or German iris) in monochromatic beds 3 feet wide in mauves, purple, and violet colors.

Myosotis asiatica. Chinese forget-me-not. Deeper blue.

Myosotis scorpioides. True forget-me-not. Lovely clear blue, readily reseeds.

Paeonia. Peony (both herbaceous and tree peonies). Yellows, coral, luscious pinks to brilliant reddish purple.

Papaver orientale. Oriental poppy. Reds, vermilion, and purplish silver, all with dark centers.

Penstemon gloxinioides. Border penstemon, garden penstemon. Pinks, reds, and white.

Primula polyanthus. Polyanthus or English primrose. Yellow, white, pink, and apricot.

Viola cornuta. Tufted pansy. White, blues, purple, yellow.

Summer Perennials:

Aconitum napellus. Garden monkshood. Blue to purple.

Alcea rosea (formerly called *Althaea rosea*). Hollyhock. Single only. White, rose, yellow, and red to deep burgundy.

ANEMONE hybrids. Japanese anemone, windflower. White only.

Aster frikartii. Lavenders, mauve, pinks, and white.

Aster novae-angliae. New England aster. Violet blue.

Aster novi-belgii. Michaelmas daisy. Lavender, pink, white, bluish tones.

Campanula medium. Canterbury bell, cup and saucer. Clear soft blue.

Delphinium elatum. Candle delphinium. Blue, planted in large stands.

Dianthus plumarius. Cottage pink. Pink flowers with silver foliage.

Digitalis purpurea. Foxglove. Tall spires of white, pink, and lavender.

Echinacea purpurea (also called *Rudbeckia purpurea*). Purple coneflower.

Eryngium alpinum. Alpine sea holly. Steel blue.

Helianthus multiflorus. Sunflower. Golden yellows.

Heliopsis scabra. Smooth oxeye. The 'Light of Loddon' variety was grown by Monet.

Hemerocallis. Daylily. Orange and yellow.

Lavandula dentata. French lavender.

Oenothera. Evening primrose. Yellow.

Pelargonium × domesticum. Martha Washington geranium.

Pelargonium × hortorum. Common or garden geranium.

Perovskia atriplicifolia. Russian sage. Periwinkle blue.

Phlox paniculata. Summer phlox. White, soft pink, and lavender blue.

Saxifraga. Saxifrage. White-bloomed varieties for edgings.
Solidago canadensis. Goldenrod. Golden yellow.
Verbascum. Mullein. Yellow, white, purplish pink.

Summer Annuals:

Antirrhinum majus. Snapdragon. Pinks, white, yellow.
Calendula officinalis. Pot marigold. Yellow.
Callistephus chinensis. China aster. Pink, white, bluish lavender.
Chrysanthemum frutescens. Paris daisy, marguerite. White.
Chrysanthemum maximum. Shasta daisy. White.
Helianthus annuus. Common sunflower. Golden yellow.
Lathyrus odoratus. Sweet pea. Pink, blue, white, and deep burgundy.
Malcolmia maritima. Virginia stock. White, yellow, pink, lilac.
Matthiola incana. Stock. White, pink, red, lavender, blue, and soft yellow.
Reseda odorata. Mignonette. Grown for its sweet, spicy fragrance. Small greenish yellow flowers.
Tropaeolum majus. Nasturtium. Trailing types used along paths. Yellow, gold, orange, and mahogany.

Shrubs:

Ceratostigma plumbaginoides. Dwarf plumbago. Ground cover with deep clear blue flowers, quite rare at the time.
Hydrangea macrophylla. Big-leaf hydrangea, garden hydrangea. Blue.
Hypericum calycinum. Creeping St. John's wort. Ground cover with gold flowers.
Jasminum nudiflorum. Winter jasmine. Yellow.
Plumbago auriculata (P. capensis). Cape plumbago. Blue.

Rosa. Climbing roses, pillar roses, shrub roses, standard roses. White, yellow, coral, pink, and red echoed the colors of the water lilies.
Syringa reticulata. Japanese tree lilac.
Syringa vulgaris. Common lilac.
VIBURNUM. Deciduous and evergreen shrubs with large white flower clusters.

Vines:

Aristolochia durior. Dutchman's pipe.
Clematis montana. Anemone clematis. Masses of both white and green flowers.
Ipomoea sp. Morning glory. Blue.
Parthenocissus tricuspidata. Boston ivy. Native to China and Japan, green leaves turn red in autumn. Grown on Monet's house and new studio.
Passiflora caerulea. Blue crown passionflower.
Wisteria floribunda. Japanese wisteria.
Wisteria sinensis. Chinese wisteria.

Trees:

Acer macrophyllum. Big-leaf maple.
Acer palmatum. Japanese maple.
Aesculus carnea. Red horse chestnut.
Laburnum. Golden chain tree.
Liquidambar. Sweet gum.
Malus floribunda. Japanese flowering crab apple.
Malus. Apple. Different varieties of edible apples.
Platanus. Plane tree, sycamore.
Prunus serrulata. Japanese flowering cherry.
Pryus communis. Pear. Comice and other varieties espaliered on walls.
Tilia europaea. European linden, lime. Small-leaved tree.

THE WATER GARDEN

Perennials:

Agapanthus praecox. Lily of the Nile. Blue.

Cortaderia selloana. Pampas grass.

Doronicum cordatum. Leopard's bane. Blooms spring to autumn. Bright yellow daisylike flowers 2 inches across.

FERN. *Athyrium filix-femina* (lady fern), *Matteuccia struthiopteris* (ostrich fern), *Polystichum braunii* (Braun's holly fern), and many other species. Monet was very fond of ferns and had an enviable collection in his greenhouse.

Geum rivale. Water avens. Numerous kinds, some slate pink.

Gunnera manicata. Gunnera is a big, bold South American foliage plant with leaves 4–8 feet across.

Hemerocallis. Daylily. Orange.

Inula helenium. Elecampane. Wild aster, 2–6 feet tall, likes moist areas. Yellow. *I. ensifolia* has yellow daisy-like flowers.

Iris ensata. Japanese iris.

Iris pseudacorus. Yellow flag iris.

Iris sibirica. Siberian iris.

Iris virginica. Southern blue flag. Light and dark blues.

Nymphaea. Water lilies (both hardy and tropical). All colors.

Petasites japonicus. Sweet coltsfoot.

Polygonatum. Solomon's seal.

Tragopogon porrifolius. Salsify, oyster plant.

Thalictrum aquilegifolium. Meadow rue. Pink and white fluffy flowers and lacy foliage.

Shrubs:

BAMBOO. *Phyllostachys nigra* (black bamboo), *Bambusa mitis, B. metake,* and many other species.

Berberis (possibly *B. thunbergii*). Japanese barberry.

Chaenomeles. Flowering quince.

Ilex aquifolium. English holly.

Kalmia. Laurel. Evergreen shrub, with elegant flowers related to rhododendrons.

Paeonia suffruticosa. Japanese tree peonies. Lavender, pink, yellow, and cream.

RHODODENDRON (including deciduous and ever-green azaleas)

Rhus typhina. Staghorn sumac.

Rosa. 'La Belle Vichyssoise'. On trees and trellises along with standard roses.

Rubus idaeus. Framboise, raspberry.

Spiraea japonica. Japanese spiraea. Pink flowers.

Spiraea × vanhouttei. Has arching branches with white flowers.

Trees:

Alnus. Alder.

Fagus sylvatica 'Atropunicea'. Copper beech.

Fraxinus excelsior. European ash. Dark purple flowers.

Fraxinus ornus. Flowering ash. White fluffy blossoms in 3–5 inch clusters.

Ginkgo biloba. Maidenhair tree. Golden yellow in autumn.

Laburnum anagyroides. Golden chain tree.

Populus nigra. Lombardy poplar.

Populus tremuloides. Quaking aspen.

Prunus serrulata. Japanese flowering cherry. Pink flowers.

Salix babylonica. Weeping willow.

Tamarix. Tamarisk. Pink featherlike flowers.

A Chronology of the Gardens

1840 Monet is born in Paris, November 14.

1854 Trade between Japan and the West begins, eventually influences European art and the Impressionist painters.

1859 Monet moves from his family home in Le Havre to study painting in Paris.

1867 Monet and Camille Doncieux have their first son, Jean. Severe financial problems.

1870 Monet and Camille marry; Franco-Prussian War begins.

1874 Historic first exhibition of Monet and his circle; a critic uses the title of a Monet painting, *Impression, Sunrise,* to describe the exhibition; the young artists keep the term and become known as the "Impressionists."

1876 Monet meets Ernest and Alice Hoschedé and receives an important commission.

1877 Ernest Hoschedé goes bankrupt and leaves the country. Alice has her second son, Jean-Pierre.

1878 Sale of Hoschedé estate; Alice and her six children move to the village of Vétheuil to live with the Monet family. Claude and Camille have their second son, Michel.

1879 Camille Monet dies of tuberculosis; Alice Hoschedé takes charge of the eight children and the household.

1883 Monet rents the large pink house in Giverny. Alice, the children, three boats, household belongings, and studio supplies are moved to Giverny. Just across the railroad track from their new home is a simple pond in a meadow.

1886 Forty-nine works by Monet are included in the first and very successful New York exhibition of Impressionist art, at the American Art Association.

1890 Monet manages to buy the pink house for 22,000 FRF. He paints locally. Raised beds full of flowers and trellises for climbing roses are added to the garden; a greenhouse is built for orchids, ferns, and other exotic plants.

1891 Ernest Hoschedé dies and is buried in Giverny.

1892 Monet and Alice Hoschedé marry. Monet purchases 2½-acre Maison Bleue for his new kitchen garden; Florimond is put in charge of orchard and vegetables. A head gardener, Félix Breuil, is hired. Eventually, four more gardeners are hired to keep up the ever-expanding gardens.

1893 Monet buys the strip of land across the railroad track to create his water garden.

1895 Monet paints his first water lily series, abstracted scenes from his own garden. His earlier series, *Haystacks, Poplars, Rouen Cathedral, Normandy Coast,* and *Mornings on the Seine,* earned Monet enormous sums of money and unprecedented accolades from critics. Monet is deemed "the premier painter of this era" (Camille Mauclair, *The Symbolist* spokesperson); "one of the crown jewels of our epoch" (Georges Lecomte, the Republican-anarchist); and "the most significant painter of the century" (conservative Raymond Bouyer).

1897 Monet builds his second studio, with apartments for his children and the ground floor (later a garage and darkroom) for the gardeners. Monet's son Jean marries Alice's daughter Blanche Hoschedé.

1898 Monet speaks out against the retrial of falsely accused Alfred Dreyfus; the Dreyfus scandal divides France and foments anti-Semitism. At the top of his career, Monet retreats to his garden to paint rather than promote the views of a government he sees as fundamentally corrupt.

1901 Monet buys land south of the Ru River and petitions to divert more water to expand his water garden; three months later he gets approval but is required to install proper sluices to regulate water flow.

1902 An enormous project to reroute the Ru begins; space is cleared to triple the size of the pond, extending it eastward. The excavated soil is used to form a small man-made island and a large area across the Japanese bridge to grow bamboo. Four bridges are built across the diverted river. The pond enchants Monet and will be his primary subject for the rest of his life.

1905 The first photographs of Monet's gardens are published in an article in *L'art et les artistes* by Louis Vauxcelles.

1907 Hoping to cut down on the amount of dust in his gardens, Monet pays for half of the paving of two Giverny roads.

1908 Monet writes a cryptic letter mentioning his eyes; the degree of his loss of vision at this time is not known. He destroys over 30 canvases of water lily paintings done over three years that he feels are overworked. He takes a break to paint in Venice; these works show the first signs of vision damage from a cataract.

1909 In Paris, Monet exhibits, to great critical acclaim, his new series of 48 water lily paintings done from 1903 to 1908 ("truly a harbinger of Nature"—Roger Marx).

1910 Severe winter storms cause the Seine to overflow, flooding the entire river valley. The water garden is submerged; water reaches halfway up the Grande Allée; all gardens are severely damaged. "With this weather I haven't managed to do anything and to add to my miseries an appalling storm has created havoc in my garden. The weeping willows I was so proud of have been torn apart and stripped; the finest broken up. In short a real disaster and real worry for me" (letter to Bernheim-Jeune). Alice becomes very ill with spinal leukemia; she undergoes radiation and is in remission late May through July.

1910– Monet repairs his water garden and decides to enlarge
1911 the pond, modifying the curvature of the banks and removing the original concrete bottom in favor of natural clay. The wisteria trellis is added to the Japanese footbridge.

1911 Alice Monet dies, May 19; Monet is grief-stricken. A long period of mourning and reclusiveness begins. Marthe Hoschedé and Blanche Hoschedé Monet oversee the Monet household. A one-man show of 45 paintings at the Museum of Fine Arts, Boston, is a great success; Monet remains in France.

1912 Monet tells friend Gustave Geffroy that a Dr. Valude has diagnosed him with a cataract—"the right eye no longer sees anything, the other is also slightly affected"—and has prescribed treatment to slow down the condition. Monet is devastated. Georges Clemenceau, a medical doctor himself, assures Monet, "You are in no danger whatsoever of losing your eyesight . . . The cataract on the bad eye will certainly soon ripen and then one could operate. But that is nothing, and the continuity of your eyesight is assured." Another great summer storm comes and damages the garden, breaking one of the weeping willows beside the pond and changing the shadow patterns of Monet's main motif.

1913 Monet paints three versions of the blooming rose arches by his pond; the beauty renews his spirit.

1914 Monet's son Jean dies after a lingering illness following a stroke two years earlier. Now widowed, Blanche becomes Monet's confidante and painting assistant. She often paints by his side and becomes an established artist in her own right. Construction of the large barnlike studio (the Atelier aux Nymphéas) is begun to enable Monet to paint the large water lily paintings. World War I begins, and Monet's son, stepson, and sons-in-law join the war effort.

Monet writes to Geffroy that he intends to do large works, departing in style from anything he has done previously: "A day finally came, a blessed day, when I seemed to feel that my [cataract] was provisionally checked. I tried a series of experiments destined to give me an account of the special limits and possibilities of my vision, and with great joy I found that although I was still insensitive to the finer shades and tonalities of colors seen close up, nevertheless my eyes did not betray me when I stepped back and took in the motif in large masses . . . While working on my sketches, I said to myself that a series of impressions of the ensemble [of the water lily pond], done at the times of day when my eyesight was more likely to be precise, would be of some interest. I waited until the idea took shape, until the arrangement and the composition of the motifs gradually became inscribed in my brain, and then when

the day came that I felt I had sufficient trumps in my hand to try my luck with some real hope of success, I made up my mind to act, and I acted."

Aug. 1: Jean-Pierre Hoschedé leaves for the front. Aug. 24: one million German troops invade France.

1915 Monet's vision worsens; he writes, "Colors no longer had the same intensity for me . . . Reds had begun to look muddy . . . My painting was getting more and more darkened." He can no longer distinguish colors well and is "on the one hand trusting solely to the labels on the tubes of paint and, on the other, to force of habit."

1916 After construction delays because of the war, the Atelier aux Nymphéas is finally completed; Monet has the obtrusive building landscaped with Boston ivy and other vines. He begins his first large panoramic water lily paintings.

1918 Monet's eyes are now about 20/100, with yellowing of the lenses from cataracts; this causes more difficulty for his painting than the blurring of his sight.

1919 Pierre-Auguste Renoir, Monet's friend and fellow Impressionist, dies. In June, Monet reports that all of the gardeners who have worked for him for the past twenty years have quit. Later in the year the household staff quits. Monet donates many paintings for benefits to aid prisoners of war.

1920 Monet, less bothered by poor eyesight, takes up painting out of doors during the mornings in the summer and in his third studio in the afternoons.

1921 Monet tells a reporter, "Alas, I see less and less . . . I used to paint out of doors facing the sun. Today I need to avoid lateral light, which darkens my colors. Nevertheless, I always paint at the times of the day most propitious for me, as long as my paint tubes and brushes are not mixed up . . . I will paint almost blind as Beethoven composed completely deaf."

1922 Monet's eye doctor records the vision in Monet's left, better eye as 20/200. With drops for this eye he can see two or three times better and wants to finish his water lilies before an operation. The result is an indistinct fog

of dark yellows and greens. Monet continues to paint his garden; the work is darker and much more abstract than either his luminous early work or the later work after his eye treatments.

1923 At 83, Monet, pressured by his dear friend Georges Clemenceau, has three operations on his right eye; eventually the cataract is successfully removed. He has been terrified to have the surgery since Mary Cassatt lost sight in one eye after her first surgery; she had retired from painting after her second operation did not restore her vision. Monet's sight improves, and he returns to work on the large water lilies. The colors and forms he paints have the clear tones reminiscent of his pre-cataract work. Monet destroys many cataract-period canvases but keeps those he feels are good. Some of these are never completed and left unsigned. Under Blanche's instructions, some canvases Monet orders burned are hidden in the garage.

Monet tries out different corrective glasses, including a pair with dark green lenses that protects his sensitive eyes in bright light; he continues his work on the water lily murals.

1926 Claude Monet dies on December 5 after completing his *Décorations des nymphéas*. From 1898 to 1926 Monet painted over 500 paintings.

1927 The magnificent water lily series of 19 panels, each 6½ feet high and up to 20 feet long, is installed in two specially constructed elliptical rooms in the Musée de l'Orangerie in Paris's Tuileries Gardens.

1927– Blanche Hoschedé Monet continues to take loving care 1947 of the Monet house and gardens, keeping it protected during the World War II occupation of Giverny. When German field marshal Rommel is appointed commander in Normandy in 1944, he is headquartered three miles away. He comes to look at the house, and although Blanche will not shake his hand, she allows him to visit; Rommel orders that the house not be occupied.

1947 Blanche Monet, Monet's only real student and his "blue angel," as Clemenceau referred to her, dies. The gardens

are no longer maintained in the manner established by Monet.

1947–
1966
House and gardens are under the supervision of Monet's surviving son, Michel. A caretaker is employed to maintain the property.

1966
Michel Monet dies, age 88, leaving the entire estate to France's Académie des Beaux-Arts. The roof of the main house is repaired; the paintings are transferred to the Musée Marmottan. For lack of funds and interest, the property and gardens fall into ruin.

1971
The contents of the studio, dozens of magnificent late paintings, are presented publicly at the Musée Marmottan in Paris.

1977
M. Gérald van der Kemp, curator of Versailles, is asked by the Institut de France to be curator of the Monet legacy in Giverny.

1977–
1978
Seed money is raised from French and American sources; renovation is slow. Fortunately, Giverny artist M. Jean-Marie Toulgouat, the great-grandson of Monet's second wife, Alice, is available to assist. Born in Giverny the year after Monet died, Toulgouat has grown up in Giverny, played in the gardens, and remembers them well. He is a great help in the authentic restoration. M. Gilbert Vahé, graduate of Ecole d'Horticulture in Versailles, becomes head gardener. Mrs. Lila Acheson Wallace, founder of the Reader's Digest Foundation, donates over one million dollars. Major renovation begins on the gardens, the pond, and the buildings.

1978
A major art show—*Monet's Years at Giverny: Beyond Impressionism*—is held at the Metropolitan Museum of Art. This show rekindles the love and interest Americans have for Monet's work.

1979
Ambassador Walter Annenberg donates funds for a tunnel under the road that divides the gardens so that visitors can safely walk from the flower garden to the water lily pond. Money from American and French sources continues to support the many aspects of restoration. Greenhouses and cold frames are constructed to raise thousands of annuals and perennials from seed.

1980
The gardens open to the public in May for the first time.

1981
Admirers of Monet and garden lovers flock by the thousands to Giverny from April 1 to October 30.

1984
The Farm Project begins to convert an old stone farm opposite Monet's house into a studio to house artists and a tea room and shop to help support the gardens.

1985
Elizabeth Murray works as the first woman gardener in Monet's gardens from April to October.

1986
The studio, shop, and teahouse at the farm are completed.

1988
The first three painters chosen from the Reader's Digest Artists at Giverny Program (administered by the College Art Association) come to Giverny.

1990
The ten-year anniversary of the opening of Monet's gardens to the public.

1992
The Musée d'Art Américain, Giverny, founded by Daniel J. Terra, opens to the public, featuring Impressionist art made by Americans in Giverny during Monet's time.

2000–
2006
Musée de l'Orangerie, Paris, is closed for the renovation of Monet's *Nymphéas.*

2006
May: The Orangerie reopens, now showcasing Monet's *Nymphéas* in natural light, the same way Monet painted them. Monet intended these two oval rooms to be "the haven of peaceful meditation, a gift to modern man with his overworked nerves."

2009
Musée des Impressionismes Giverny opens, replacing the Musée d'Art Américain; its inaugural exhibition is *Monet's Garden in Giverny: Inventing the Landscape.*

VOCABULARY OF COLOR

CHROMA

Strength, saturation, purity, brilliance, intensity, brightness, or dullness of a color.

COLOR AND DISTANCE

As distance increases, saturation is reduced. Thus lighter colors can be employed to create more of a sense of distance.

COLOR AND LIGHT

The light at dawn and dusk distorts perception of color. Under these circumstances, light colors need more intensity and dark colors less intensity.

COMPLEMENTARY COLORS

Red and green, blue and orange, yellow and purple. When placed side by side, each makes the other appear more intense; when mixed they create a neutral gray or black.

CONTRAST

A distinct difference between two parts of the same color dimension, which may range from subtle to strong hues that are diametrically opposite each other.

COOL COLORS

Blues, greens, and violets. These colors seem to recede.

DIMENSION OF COLOR

A measurable visual quality of color. Each color has three dimensions: hue, value, and chroma. Each may theoretically be altered without disturbing the others.

HUE

The name of a color and one of its three dimensions.

KEY COLOR

Dominant color in a color scheme or mixture.

MONOCHROMATIC

Any combination of shades, tints, or tones of one color. For example, a possible monochromatic color scheme could range from pale pink to red, deep magenta, and nearly black.

PURE COLOR

A clear hue with no shade, tint, or tone added; pure colors have more intensity and clarity.

SATURATION

Strength of color, chroma, purity, brilliance, intensity.

SHADE

Color resulting from the addition of black to a pure hue. To obtain livelier, deeply saturated shadows, Monet would add complementary colors instead of black.

TEXTURE

Surface quality; can absorb or reflect light and has different tactile qualities.

TINT

Color resulting from the addition of white to a pure hue.

TONE

Color resulting from the addition of gray to a pure hue.

VALUE

Lightness or darkness of a color. For example, red and pink flowers together exhibit the same hue with different values.

WARM COLORS

Yellows, oranges, and reds. These colors seem to advance toward the viewer.

Monet's Color Palette

As for the colors I use, what's so interesting about that? I don't think one could paint better or more brightly with another palette. The most important thing is to know how to use the colors. Their choice is a matter of habit. In short, I use white lead, cadmium yellow, vermilion, madder, cobalt blue, chrome green. That's all.

—Claude Monet

WHITE LEAD, also known as flake white, is the most structurally sound white paint for underpainting linen or cotton canvas, combining flexibility, toughness, and permanence not found in other paints. It is highly toxic, especially to children; substitutes include titanium white and zinc white, which are less opaque and better for misty glazes.

CADMIUM YELLOW is a clear, colorfast yellow made with sulfides, which makes it toxic.

VERMILION, an orangish red opaque pigment used since antiquity, was originally derived from the powdered mineral cinnabar, which is toxic mercuric sulfide.

DEEP ROSE MADDER, a warm red color derived from the madder root, was replaced in the latter part of the nineteenth century by alizarin crimson, a synthetic form of madder that was thought to create a more permanent color. Preferred as a substitute by many artists, it makes beautiful violets when mixed with blue, and perfect blacks and neutrals when mixed with dark green.

COBALT BLUE is an extraordinarily stable cool blue historically made from cobalt salts.

CHROME GREEN, also called viridian, is a clear blue green pigment (patented in France in 1859); it was so popular many people thought it would eventually replace all other greens. Monet sometimes used emerald green, named after the gemstone. Light and bright with a faint bluish cast, it is a softer color with more concentrated pigment than viridian.

The Impressionist painters did not use pure black. Monet obtained an appearance of black by combining several colors: blues, greens, and reds. Depending on what was in shadow, he might add a dark blue, and in a painting of red boats he included shadows in dark, cool purple.

Avoiding black was so deeply anchored in Monet's persona, that when he died his friend Georges Clemenceau tore off the black cloth covering his coffin, exclaiming: "No! No black for Monet!" He replaced the crepe with a flowered curtain, in keeping with Monet's lifetime love of flowers and color.

BIBLIOGRAPHY

Brenzel, Kathleen Norris. *Sunset Western Garden Book*. 8th ed. Menlo Park, CA: Sunset, 2007.

Brody, Jane E. "An Operation That Made Everything Clear." *The New York Times,* March 20, 2007, Health section.

Brown, Jonathan. "How Monet's Cataracts Coloured His View of the Lilies." *The Independent,* May 16, 2007, Science section.

Chevreul, M. E. *The Principles of Harmony and Contrast of Colors, and Their Application to the Arts.* Translated by Charles Martel. 3rd ed. London: Bell & Daldy, 1870.

Claude Monet Vaerker fra 1880 til 1926. Humlebæk, Denmark: Louisiana Museet, 1993. An exhibition catalog.

Doyle, Michael E. *Color Drawing.* New York: Van Nostrand Reinhold, 1981.

Gordon, Robert, and Andrew Forge. *Monet.* New York: Abradale Press, Harry N. Abrams, 1989.

House, John. *Monet, Nature into Art.* New Haven, CT: Yale University Press, 1986.

Howard, Michael. *The Treasures of Monet.* Andre Deutsch and Musée Marmottan, 2007.

Joyes, Claire. *Claude Monet: Life at Giverny.* New York: Vendome Press, 1985.

———. *Monet at Giverny.* New York: Mayflower Books, 1975.

———. *Monet's Table: The Cooking Journals of Claude Monet.* Translated by Josephine Bacon. New York: Simon & Schuster, 1989.

Kemp, Gérald van der. *A Visit to Giverny.* Translated by Bronia Fuchs. Versailles: Éditions d'Art Lys, 1986.

Kendall, Richard, ed. *Monet by Himself: Paintings, Drawings, Pastels, Letters.* New York: Knickerbocker Press, 1996.

Marmor, Michael F. "Ophthalmology and Art: Simulation of Monet's Cataracts and Degas' Retinal Disease." *Archives of Ophthalmology* 124, no. 12 (Dec. 2006): 1764–69.

Marmor, Michael F., and James G. Ravin. *The Artist's Eyes: Vision and the History of Art.* New York: Harry N. Abrams, 2009.

Monet's Years at Giverny: Beyond Impressionism. New York: Metropolitan Museum of Art, 1978. An exhibition catalog.

Orr, Lynn Federle, Paul Hayes Tucker, and Elizabeth Murray. *Monet: Late Paintings of Giverny from the Musée Marmottan.* New York: Harry N. Abrams, 1994. An exhibition catalog.

Paul, Anthony, and Yvonne Rees. *The Water Garden.* London: Penguin, 1986.

Pereire, Anita, and Gabrielle van Zuylen. *Gardens of France.* New York: Harmony Books, 1983.

Rewald, John. *The History of Impressionism.* 4th ed. New York: Museum of Modern Art, 1973.

Roskill, Mark. *The Languages of Landscape.* University Park, PA: Pennsylvania State University Press, 1997.

Stuckey, Charles F. *Claude Monet, 1840–1926.* New York: Thames and Hudson, 1995.

———, ed. *Monet: A Retrospective.* New York: Park Lane, 1985.

Wildenstein, Daniel. *Claude Monet: biographie et catalogue raisonné.* 5 vols. Lausanne, Switzerland: Bibliothèque des Arts, 1974.

FURTHER READING

Björk, Christina, and Lena Anderson. *Linnea in Monet's Garden.* New York: R & S Books, 1987.

Bradley, Fern Marshall, Barbara W. Ellis, and Ellen Phillips, eds. *Rodale's Ultimate Encyclopedia of Organic Gardening: The Indispensable Green Resource for Every Gardener.* New York: Rodale, 2009.

Johnson, Wendy. *Gardening at the Dragon's Gate: At Work in the Wild and Cultivated World.* New York: Bantam, 2008.

Louv, Richard. *Last Child in the Woods: Saving Our Children from Nature-Deficit Disorder.* Chapel Hill, NC: Algonquin Books, 2005.

Tallamy, Douglas W. *Bringing Nature Home: How Native Plants Sustain Wildlife in Our Gardens.* Portland, OR: Timber Press, 2007.

WEB RESOURCES

Botanical Society of the British Isles
www/bsbi.org.uk

Butterflies and Moths of North America
www.butterfliesandmoths.org

Children & Nature Network
www.childrenandnature.org
Reconnecting children and nature.

Elizabeth Murray
www.elizabethmurray.com
Lectures, art, garden consultation, and more.

Euro+Med PlantBase
www.emplantbase.org
Information and resources for European-Mediterranean plant diversity.

Lady Bird Johnson Wildflower Center
www.wildflower.org

Musée de l'Orangerie
www.musee-orangerie.fr.
The most beautiful virtual experience of Monet's waterlily paintings; wonderful text, in French.

National Garden Bureau
www.ngb.org
Growing information for specific plants.

National Gardening Association
www.garden.org
Gardening tips for US gardeners.

Natural Resources Conservation Service
www.plants.usda.gov | www.nrcs.usda.gov
Excellent resource for plants in the United States, including 40,000 images and lists of plants for pollinators.

North American Pollinator Protection Campaign
www.nappc.org
Support nature in your garden by supporting pollinators.

Organic Gardening
www.organicgardening.com
Become an organic gardener—Monet was one.

Plant Conservation Alliance
www.nps.gov/plants

Pollinator Partnership
www.pollinator.org
Support nature in your garden by supporting pollinators.

Seeds of Success
www.nps.gov/plants/sos

Seed Savers Exchange
www.seedsavers.org

USDA Hardiness Zone Map
www.usna.usda.gov/Hardzone/ushzmap.html

United States National Arboretum
www.usna.usda.gov

Water Garden Supplies
www.lilypons.com | www.vnwg.com
www.watergardening.com | www.watergarden.com

Williamsburg Art Materials
www.williamsburgoilpaint.bizland.com

FOLLOWING PAGE: *One of the gardeners tiptoes down the Grande Allée, careful not to crush any nasturtium leaves. He carries his long pole pruners to deadhead spent blooms on the tallest plants. The mist obscures the rest of the garden, but the early morning light illuminates the gold and orange flowers and makes the round disks of the nasturtium leaves glow like stained glass.*

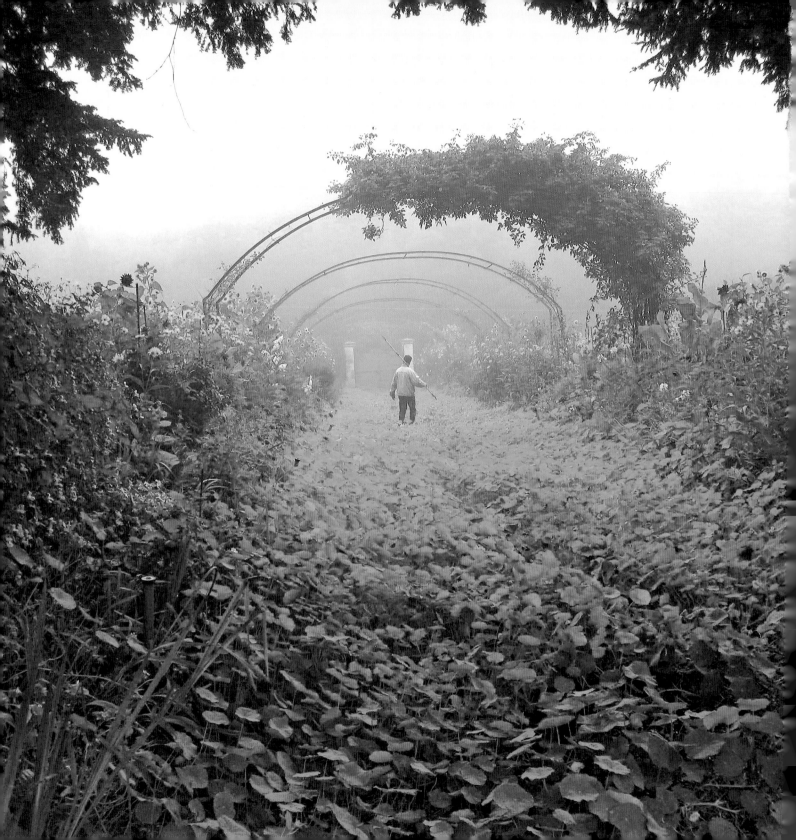